# ANGLESEY
## IN
# 50
## BUILDINGS

# WARREN KOVACH

AMBERLEY

First published 2017

Amberley Publishing, The Hill, Stroud
Gloucestershire GL5 4EP

www.amberley-books.com

British Library Cataloguing in Publication Data.
A catalogue record for this book is available from the British Library.

ISBN 978 1 4456 7256 4 (print)
ISBN 978 1 4456 7257 1 (ebook)

Origination by Amberley Publishing.
Printed in Great Britain.

# Contents

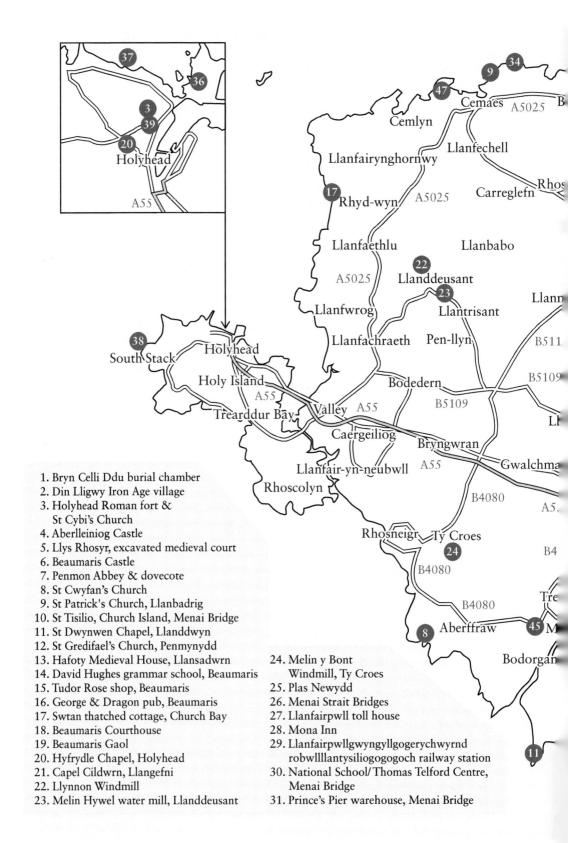

1. Bryn Celli Ddu burial chamber
2. Din Lligwy Iron Age village
3. Holyhead Roman fort &
   St Cybi's Church
4. Aberlleiniog Castle
5. Llys Rhosyr, excavated medieval court
6. Beaumaris Castle
7. Penmon Abbey & dovecote
8. St Cwyfan's Church
9. St Patrick's Church, Llanbadrig
10. St Tisilio, Church Island, Menai Bridge
11. St Dwynwen Chapel, Llanddwyn
12. St Gredifael's Church, Penmynydd
13. Hafoty Medieval House, Llansadwrn
14. David Hughes grammar school, Beaumaris
15. Tudor Rose shop, Beaumaris
16. George & Dragon pub, Beaumaris
17. Swtan thatched cottage, Church Bay
18. Beaumaris Courthouse
19. Beaumaris Gaol
20. Hyfrydle Chapel, Holyhead
21. Capel Cildwrn, Llangefni
22. Llynnon Windmill
23. Melin Hywel water mill, Llanddeusant

24. Melin y Bont
    Windmill, Ty Croes
25. Plas Newydd
26. Menai Strait Bridges
27. Llanfairpwll toll house
28. Mona Inn
29. Llanfairpwllgwyngyllgogerychwyrnd
    robwllllantysiliogogogoch railway station
30. National School/Thomas Telford Centre,
    Menai Bridge
31. Prince's Pier warehouse, Menai Bridge

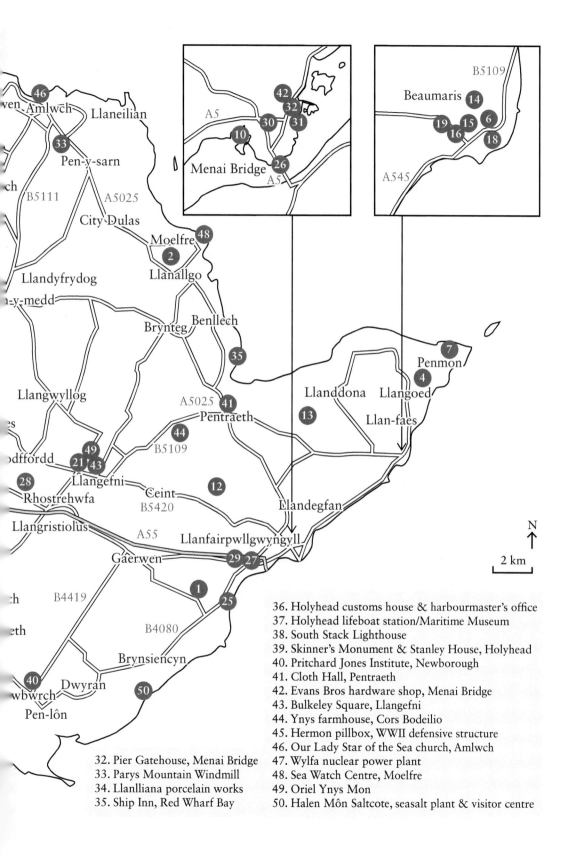

46 Amlwch Llaneilian
33 Pen-y-sarn
B5111 A5025
City Dulas
Moelfre 48
2
Llanallgo
Llandyfrydog
x-y-medd
Brynteg Benllech
35
Llangwyllog
A5025 41
44 Pentraeth
B5109
49
21 43
28 Llangefni
Rhostrehwfa Ceint
B5420
Llangristiolus
A55
Gaerwen
B4419
1
25
B4080
Brynsiencyn
40 Dwyran
wbwrch 50
Pen-lôn

**Inset (top centre):**
A5
42
32
30 31
10
Menai Bridge
26
A5

**Inset (top right):**
B5109
Beaumaris 14
19 15 6
16
18
A545

Llanddona Llangoed
7
Penmon
4
Llan-faes
13
12
Llandegfan
Llanfairpwllgwyngyll
29 27

N
↑
2 km

32. Pier Gatehouse, Menai Bridge
33. Parys Mountain Windmill
34. Llanlliana porcelain works
35. Ship Inn, Red Wharf Bay

36. Holyhead customs house & harbourmaster's office
37. Holyhead lifeboat station/Maritime Museum
38. South Stack Lighthouse
39. Skinner's Monument & Stanley House, Holyhead
40. Pritchard Jones Institute, Newborough
41. Cloth Hall, Pentraeth
42. Evans Bros hardware shop, Menai Bridge
43. Bulkeley Square, Llangefni
44. Ynys farmhouse, Cors Bodeilio
45. Hermon pillbox, WWII defensive structure
46. Our Lady Star of the Sea church, Amlwch
47. Wylfa nuclear power plant
48. Sea Watch Centre, Moelfre
49. Oriel Ynys Mon
50. Halen Môn Saltcote, seasalt plant & visitor centre

# Introduction

During the last ice age 20,000 years ago, snow covered the land. Glaciers from Snowdonia and the north of England flowed across Anglesey and carved out two valleys, one along what is now the Menai Strait, and another between Red Wharf Bay and Malltraeth. By 5,000 years ago the ice had melted, the sea level had risen, and Anglesey was an island.

The earliest humans arrived in the area around 8,000 years ago. At this time the land was covered by a forest of oak, elm, hazel and birch in which people hunted and gathered food. Later settlers brought agricultural techniques and gradually began to cut down these forests to clear land for farming.

These early settlers also built increasingly impressive ritual and burial structures. The Anglesey landscape is dotted with the resulting standing stones, burial mounds and passage tombs. The round foundations of their thatch-roofed huts can also be found widely, some fully excavated and visible, and others just a hint of the stone walls under the soil.

The island entered written history in the Roman times. After the Romans occupied Wales in the first century AD, Anglesey was one of the last strongholds of the Celts and their Druidic priests, who were maintaining native resistance against the Romans. The Roman historian Tacitus gives an account of a battle on the shores of the Menai Straits, in which the Romans sought to defeat the druids. He spoke of 'men and weapons, woman running between them, like the Furies in their funereal clothes' and 'Druids among them, pouring out frightful curses with their hands raised high to the heavens'. Although initially petrified, the Romans eventually won the battle, subdued the Druids and cut down their groves of sacred oaks.

The Romans withdrew from Wales in the fourth century. Anglesey then came under the influence of the kings of Dublin. Numerous raids occurred and it is likely that the Irish settled in parts of the island. Soon war broke out in which the Welsh, supported by Celts from the north of England, vanquished the Irish from the island.

The early medieval period saw the rapid growth of the Celtic Christian church throughout Britain and Ireland. On Anglesey several monastic settlements were founded, but these became the target of much destruction from Viking raids. After the end of Viking activity in the twelfth century, Anglesey again flourished, with many churches being built or rebuilt in stone. A number of these medieval buildings are well preserved and are still in use today.

At this time Anglesey had been ruled by the Princes of Gwynedd since the days of Rhodri the Great in the ninth century. Two royal courts were founded on the Island, one at Aberffraw and another at Rhosyr, near present-day Newborough, and the royal lineage was called the House of Aberffraw. But, in the thirteenth century, conflict broke out between Wales and England, which was now ruled by the descendants of the Norman invaders. Edward I of England twice launched campaigns against Llywelyn ap Gruffydd, the last Prince of Wales. Llywelyn was defeated in part because Edward cut off grain shipments

from Anglesey that were feeding his army. Afterwards Edward built a series of castles around the coast of Wales to subdue the natives, including Beaumaris Castle on Anglesey and Caernarfon Castle, just across the strait on the mainland.

Anglesey has a link to another royal dynasty. The ancestors of Henry Tudor, later Henry VII and founder of the Tudor dynasty, hailed from Plas Penmynydd. The full story is told in the section on St Gredifael's Church.

From the eighteenth century onwards Anglesey became important for two reasons: copper and travel to Ireland. Copper mining had been taking place at Parys Mountain since at least the Roman period – perhaps much earlier. In the 1760s, demand for metal for the production of guns, metal plating for ships, and coinage led to mining being expanded. At its peak Parys Mountain was the largest copper mine in the world and employed 1,500 people. The end of the Napoleonic Wars meant a reduction in the demand for copper and a sudden decline in the fortunes of the mine.

Many of the coastal bays on Anglesey had served as small ports throughout the ages, but by the eighteenth century Holyhead had emerged as the main port, primarily because it is the closest point to Ireland. The union of Great Britain and Ireland in 1800 increased the need to make the route from London to Holyhead easier to travel. In 1810, Thomas Telford was commissioned to build a new road through North Wales and across Anglesey. This included the first major suspension bridge in the world, the Menai Bridge, across the Menai Strait, opened in 1826. The coming of the railways two decades later led to the building of Robert Stephenson's innovative tubular bridge, the Britannia Bridge, to carry trains across the strait.

Through the later nineteenth century and into the twentieth, the population of the island dropped from 57,000 to 49,000. The copper industry and other small-scale factories had declined, mechanization of agriculture meant less need for field labourers, and the higher wages of the industrialised cities in England beckoned. But, at the same time, tourism became increasingly important, as steamers from Liverpool, then motorcars from all over, began arriving at the Menai Strait. After the Second World War, several major industries became established, including the aluminium smelter near Holyhead, a nuclear power plant by Cemaes, and a bromine extraction plant at Amlwch. These have now all sadly closed, but other small-scale industries have developed, including a recent spurt in growth of innovative local food producers and fine restaurants, and tourism continues to be a major employer for the current 69,000 residents.

Anglesey's history spans a long and varied period, and I've tried to select fifty buildings in this book to illustrate this diversity. I hope this book will help you enjoy exploring the history of this fascinating island.

Warren Kovach
July 2017
www.anglesey-history.co.uk

# The 50 Buildings

### 1. Bryn Celli Ddu Burial Chamber

This is one of the most impressive and evocative prehistoric monuments on the island. As you approach it you feel as if you are walking back in time to the Neolithic. The reconstructed mound appears similar to what it would have looked like when it was built. Indeed it is often used by modern-day Druids for solstice ceremonies and for demonstrations by archaeological groups.

Bryn Celli Ddu (which means 'Mound in the Dark Grove') is a passage tomb. A narrow passage leads to a chamber in the middle of the mound, where the remains of the dead were interred, and where rituals were probably performed. When it was first excavated

*Below left*: Bryn Celli Ddu.

*Below right*: Patterned stone at Bryn Celli Ddu.

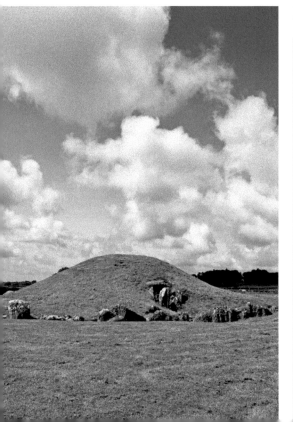
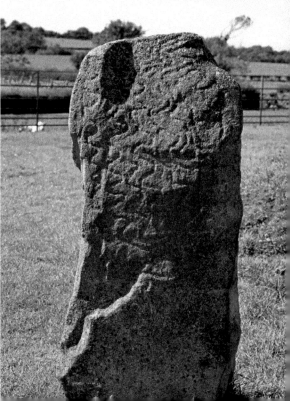

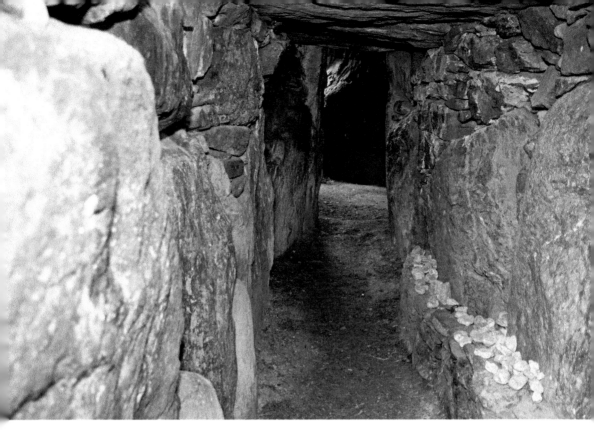

The passage and chamber of Bryn Celli Ddu.

human bones, burnt and unburnt, were found in the chamber, along with arrowheads, stone beads and limpet and mussel shells. Intriguingly, the passage is aligned so that the rays of the sunrise on the summer solstice light up the passageway, suggesting its use for seasonal rituals. Other monuments, like Stonehenge in England and Newgrange in Ireland, are known to be aligned to the solstice sun, but this is the only passage tomb on Anglesey with such a distinctive alignment.

When it was first described in the eighteenth and nineteenth century there was no mound over it, just the stones of the partially collapsed passage and chamber. By the 1920s, trees growing through the stones threatened to destroy the monument, so they were carefully removed, the site explored by archaeologists and the stones stabilized. It was again covered by a mound of soil, to protect the stones and recreate its original appearance. The current mound is smaller than the likely size of the original mound, so that the inner chamber could be partially open to allow light in.

During excavation, a stone was found lying flat that was covered with complex carvings, including spirals and maze-like zigzags. It is thought that this stone predated the passage grave and may have formed part of an earlier henge structure that was composed of a circular ditch and bank, and a series of standing stones. The original carved stone is now in the National Museum of Wales in Cardiff, and a replica has been erected at the site.

Another pillar-like standing stone can be found within the chamber. It is too short to have been a structural part of the tomb, and may have had ritualistic meaning. Some have noted that its rough surface resembles a tree trunk and have suggested it might be petrified wood, but it is actually a metamorphic rock, blueschist, not a fossil.

## 2. Din Lligwy Iron Age Village

A stroll across pasture land to the top of a small tree-covered hill brings you back 2,000 years. This spot, overlooking the Irish Sea near Moelfre, is the location of the Din Lligwy Iron Age village. It is an excellent example of a fortified hut group, dating from the latter days of the Roman occupation. Coins and pottery found here have been dated from the fourth century AD, although excavations and finds of earlier structures suggest that it was in use long before that.

The site covers half an acre and consists of the foundations of a number of buildings, with the entire area enclosed by a thick double wall, filled in with rubble. The size and shape of the buildings vary, suggesting different purposes.

The round buildings are typical of Iron Age domestic dwellings, many of which were scattered around Anglesey. Excavations in the largest one (shown in the photo) have revealed Roman coins, pottery and a glass jug as well as a silver ingot. This one is thought to have been the chieftain's hut. Another smaller round hut stands at the other side of the village. These huts would have been topped with conical roofs of thatch, much like the ones that have been recreated at Llynnon Mill (shown in the adjacent photograph).

The biggest rectangular building was found to contain large amounts of metallic slag as well as remains of several hearths with charcoal formed from oak. It was evidently a workshop for the smelting and working of iron. The entrance to the

Din Lligwy round hut.

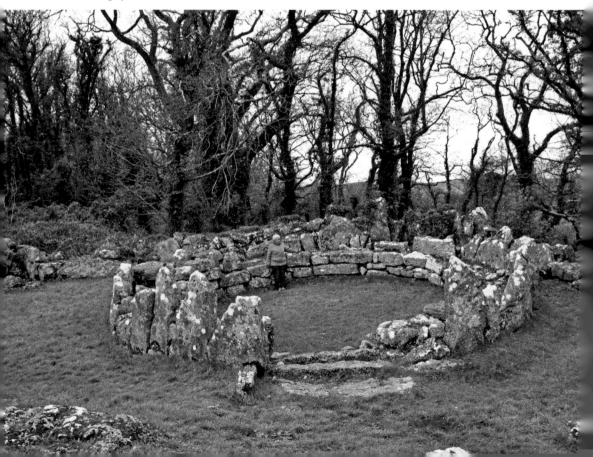

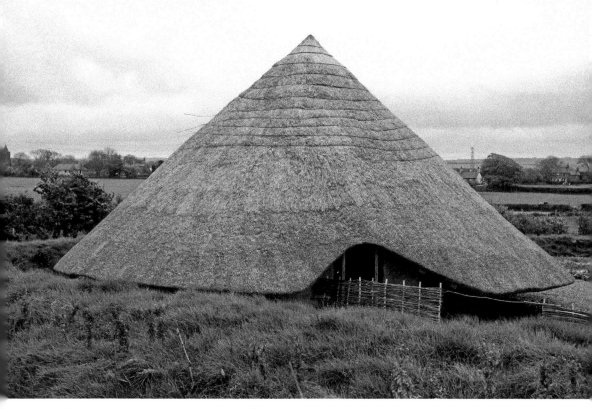

Re-created round hut near Llynnon Mill.

fortified compound was through a rectangular building, in which the village's livestock would have been housed.

Although dating from the Roman period, the occupants were probably local Celtic people, as evidenced by their preference for traditional round houses. However, the building of rectangular workshop buildings shows Roman influence, and the presence of imported pottery and glass suggests that they were relatively wealthy.

## 3. Holyhead Roman Fort and St Cybi's Church

The Welsh name for Holyhead is Caergybi, which means 'Cybi's fort'. However, before St Cybi's time it was the Romans' fort.

The Romans arrived in Wales in the first century AD and invaded Anglesey in AD 60. Their main permanent presence in the area was built eighteen years later at Segontium, near Caernarfon. However, later in their period of occupation, a fort was built overlooking the sea at Holyhead, probably in response to raiding parties from Ireland. At the same time a lookout post was built on top of Holyhead Mountain.

The ancient walls of this Roman fort are still standing and in good condition. It is unusual because it consists of just three walls, with towers at the corners. The eastern side of the fort is atop a cliff above the harbour, where there may have been an enclosed quay. A modern wall has been built on top of this cliff, and some of the towers have been rebuilt at various times through the ages.

The fort was probably abandoned in the late fourth century, when the Roman troops began pulling out of Wales in response to revolts elsewhere in the empire. Two hundred

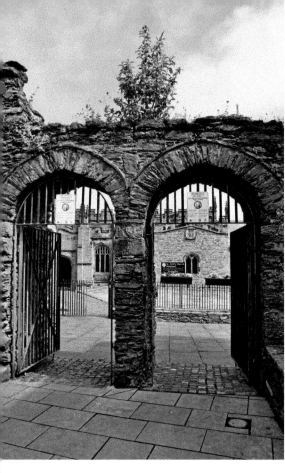

*Left*: Gateway through the Roman wall into St Cybi's Churchyard.

*Below*:  The Roman wall at the back behind St Cybi's Church and Eglwys-y-Bedd Chapel.

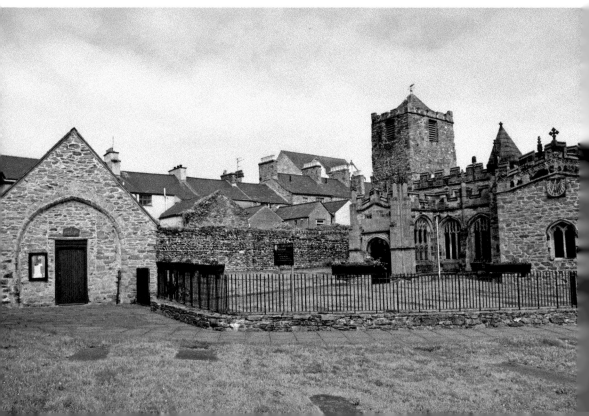

years later St Cybi, a cousin of the Welsh patron saint David was searching for a site for a monastery. Maelgwyn, the King of Gwynedd, gave him the fort, where he built his church and settlement within the old walls. Cybi died in AD 555 and was buried in the southwest corner of the fort, where the fourteenth-century Eglwys-y-Bedd chapel now stands.

Cybi's original church is long gone, but parts of the chancel of the current church have been dated to the thirteenth century. It was greatly extended in the fifteenth and sixteenth centuries with the addition of the nave, aisles and transepts. The tower was added in the seventeenth century. In 1897, a chapel, designed by Hamo Thornycroft, was added to the south side of the chancel. It was built to house the angel-flanked tomb of the Hon. W. O. Stanley of Penrhos, a prominent local landowner and well-respected archaeologist and historian.

## 4. Aberlleiniog Castle

This may not be as impressive as its bigger brother down the road in Beaumaris, but Aberlleiniog Castle, near Llangoed, is an interesting and peaceful place to visit. A short walk from the village centre leads you to a mound surrounded by trees, and topped with the low walls and towers of a fort.

A castle was first built here in 1088, 200 years before Beaumaris Castle. It was commissioned by Hugh d'Avranches, Earl of Chester. Born into an aristocratic family in

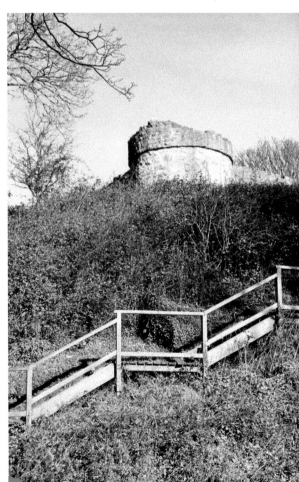

Stairs up the mound to Aberlleiniog Castle.

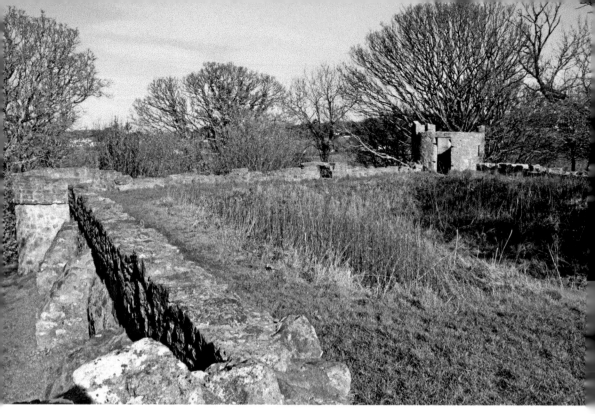

Aberlleiniog Castle.

Normandy, he became a councillor to William the Conqueror after the invasion of England in 1066. He was rewarded with the Earldom of Chester, and subsequently turned his eyes across the border to Wales. He and his cousin Robert of Rhuddlan subdued North Wales and captured Gruffydd ap Cynan, King of Gwynedd, in 1081. He then built Aberlleiniog Castle in a key strategic location, overlooking the mouth of the Menai Strait. Gruffydd escaped from his capture and, in 1094, led a revolt against the Norman overlord. He besieged the castle and eventually plundered and burned it. The Normans were driven out of Anglesey and Gwynedd, leaving the native Welsh again in charge until Edward I's invasion.

The original castle followed the usual Norman pattern of a motte-and-bailey. A mound (motte) was built with a fenced area, the bailey, surrounding it. A wooden castle was then built on top of the mound. After this was burned down by Gruffydd, little is known about the castle until the seventeenth century. It was then during the Civil War that Thomas Cheadle, Constable of Beaumaris, built (or perhaps rebuilt) a square stone fort on the mound. He initially supported the Royalists, but later switched to the Parliamentarians, and the fort may have housed soldiers preparing to storm Beaumaris Castle.

Since then one of the round towers in the corners of the fort has been turned into a summer house, which was also used as an observation post during the Second World War. In 2004, it was purchased by Mentor Môn, Anglesey's Enterprise and Rural Development Agency. At the time it was in poor condition and difficult to get to – visitors needed to scramble up the steep sides of the mound. So, new boardwalks and steps were built to ease access. In 2013, a £317,500 grant was received from the Heritage Lottery Fund to restore the castle, with the stonework repaired and strengthened.

## 5. Llys Rhosyr, Excavated Medieval Court

In medieval days, princes and kings didn't rule from one central capital. A number of courts were established throughout their lands, and they would regularly travel between them. Each court would also serve as an administrative centre for that subdivision (called commotes in Wales) of the kingdom.

It has long been known that one royal court existed in Aberffraw, as the lineage of the Princes of Gwynedd originated here; indeed, Llywelyn the Great was known as 'Prince of Aberffraw and Lord of Snowdonia'. The likely site of that court now lies under the houses of the town, so hasn't been explored by archaeologists.

However, in the early 1990s several pieces of evidence were found that pointed towards the location of another court that was thought to exist near Newborough. In particular, the eighteenth-century Anglesey antiquarian Henry Rowlands wrote of old stone walls briefly being revealed in a field next to the church after a storm, and a local farmer told an investigating archaeologist that the field was called *Cae Llys* ('Court field' in Welsh). A short period of digging revealed bits of medieval pottery. With growing anticipation of what might lay underneath, funding was raised to excavate the site. They uncovered three buildings, including what seems to be the main hall, as well as part of a perimeter wall. Coins, pottery and animal bones found at the site have been dated to the thirteenth century, the time of the height of the powers of the Princes of Gwynedd.

The conquest of North Wales by Edward I in 1282 led to the abandonment of this and other Royal courts. A huge storm in 1332 buried the site under a thick layer of sand, preserving it well from centuries of agricultural activity above. After the excavations of the 1990s the uncovered walls have been preserved and information boards erected, so visitors can wonder at what the site must have been like when the Princes trod the soil.

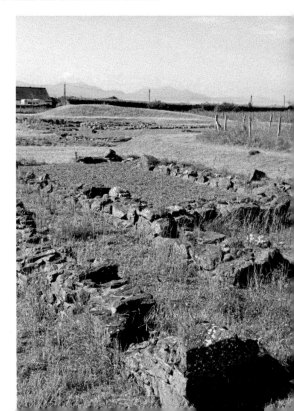

The perimeter wall and one of the buildings of Llys Rhosyr.

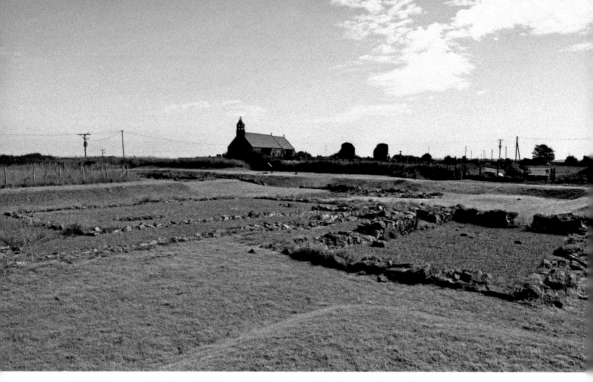

Llys Rhosyr main hall on the left, with the private chambers on the right.

In 2014, work began at the open-air historical park of St Fagans National Museum of History, near Cardiff, to recreate the buildings and enclosure of Llys Rhosyr. Called Llys Llywelyn, it will take its place alongside more than forty historic buildings, ranging from churches and cottages to industrial buildings and schoolhouses, which have been re-erected in the park to take visitors back in time to explore the history of Wales.

## 6. Beaumaris Castle

One of the most popular tourist attractions on Anglesey, Beaumaris Castle, presides over the town from its location at the top of the High Street. Although unfinished, it is considered 'one of the finest examples of late thirteenth-century and early fourteenth-century military architecture in Europe', in the words of UNESCO, which has declared it a World Heritage Site, along with Conwy, Caernarfon and Harlech castles.

These castles were all built by Edward I after he conquered North Wales in 1282. Beaumaris was the last to be built, with work starting in 1295, overseen by Edward's architect, Master James of St George. It is one of the best examples of a symmetrical concentric castle. It consists of a square inner ward with a wall, six towers and two gateways. This was enclosed by another wall, eight-sided, again with two gateways and numerous towers. The whole was surrounded by a moat, which led directly to the sea at the nearby Menai Strait.

Although a great deal of work was done on the castle in the first two years, progress slowed and eventually stopped by 1300, when debts had mounted and Edward became distracted by his wars in Scotland. Work was done intermittently for the next thirty years, but the castle was not finished to its intended design. The towers and gatehouses were never completed to their full heights, and the planned accommodation buildings in the inner ward were never built.

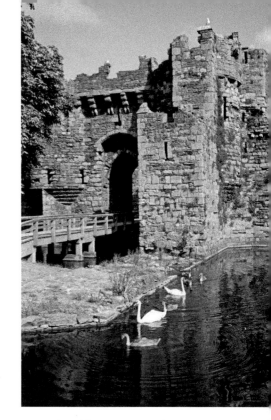

*Right*: The moat and gateway into Beaumaris Castle.

*Below*: Beaumaris Castle.

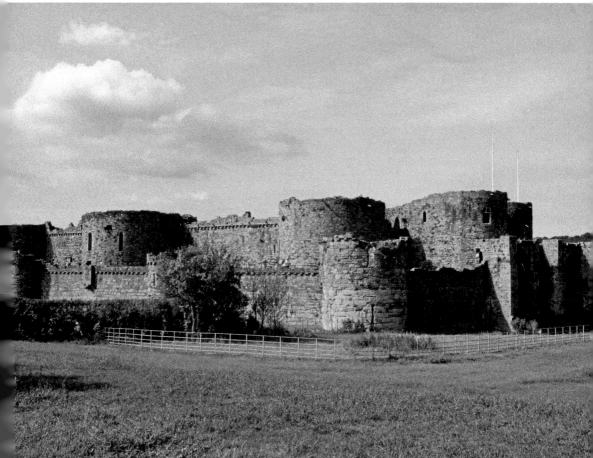

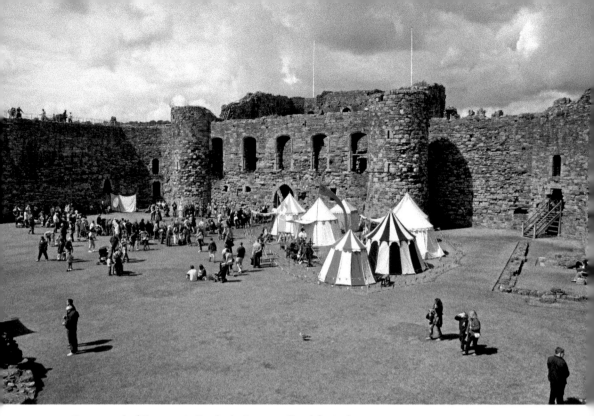

Inner ward of Beaumaris Castle during a medieval festival.

During Owain Glyndŵr's revolt against English rule, the castle was captured by his army for two years, but was retaken by the royal forces in 1405. It saw little use after this and fell into disrepair through the centuries. It was refortified at the outbreak of the Civil War in 1642, during which it was occupied by Royalists, then Parliamentarians, then Royalists again.

In 1807, Thomas Bulkeley of Baron Hill, whose family had been castle constables for generations, bought the castle from the Crown for £735. Its ivy-covered ruins became a focus of Victorian romantic interest, and the Bulkeleys built a tennis court in the inner ward. They gifted it to the State in 1925, after which a major restoration was carried out and it was opened to the public.

## 7. Penmon Abbey and Dovecote

The sixth century saw a rise of the Christian Church throughout the Celtic world and the growth of monasteries in remote places to follow ascetic lifestyles. On Anglesey, two monasteries were formed at opposite ends of Anglesey by two friends, Seiriol and Cybi. St Cybi's monastery was in Holyhead, and St Seiriol took up residence in Penmon, at the northeast end of the island. According to legend, the two saints used to walk to the centre of the island to meet every week. St Cybi faced the rising sun in the morning, and the evening sun on his return journey, while St Seiriol always had the sun to his back. They were thus known as Cybi the Dark (since he was tanned during his journey) and Seiriol the Fair.

St Seiriol's monastery grew and by the tenth century it had a wooden church building and two high crosses at the entrance to the monastic grounds. However, Viking raids in 971 destroyed

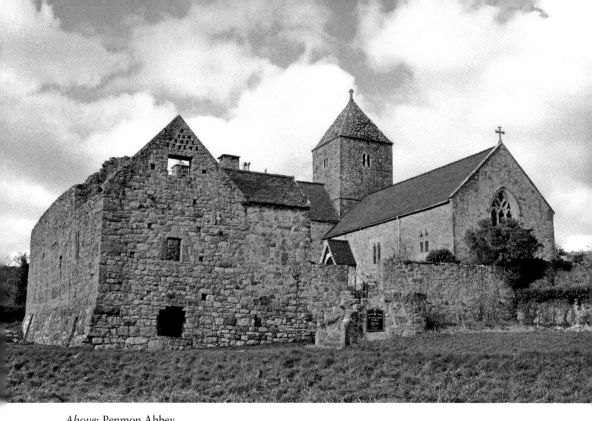

*Above*: Penmon Abbey.

*Below*: Penmon dovecote.

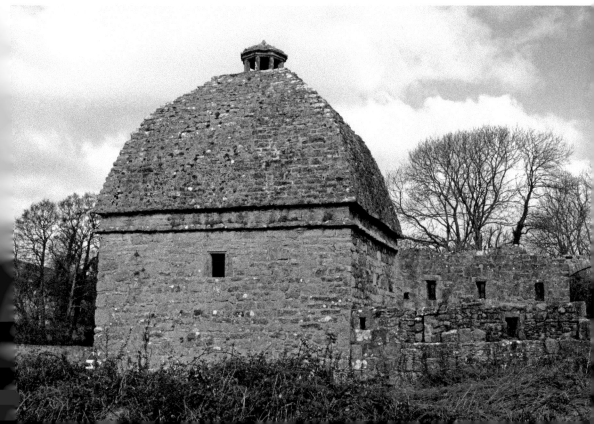

the church. Rebuilding of the church in stone took place throughout the twelfth century during the prosperous period under the rule of Gruffydd ap Cynan and Owain Gwynedd.

The main church building is still in use today, but the large building in front is roofless. This was the refectory, a three-storey building that housed a dining hall, cellars and a dormitory for the monks. Connecting the refectory and the south transept of the church was the prior's house, built in the sixteenth century and now a private residence.

Penmon closed when the monasteries were dissolved in 1537, under the reign of Henry VIII. At this time the lands passed into the hands of the local landowners, the Bulkeley family, who used it as a deer park. The church remained in use, however, and much of it was rebuilt in 1855.

Near to the abbey stands a curious square building with a large domed roof. This building, built by the Bulkeleys around 1600, is a dovecot, used to house domestic pigeons for their eggs and meat. The small cupola on the top allowed the birds to fly in and out. Inside were 1,000 nesting boxes to accommodate the doves and a central pillar to support a ladder to provide access to the boxes.

## 8. St Cwyfan's Church

Perched on a tiny island called Cribinau, encircled by a sea wall, is a simple medieval church dating to the twelfth century. It is popularly known as the Church in the Sea, but is properly called St Cwyfan's. It is thought to be dedicated to the Irish St Kevin, who founded the monastery across the sea at Glendalough in Co Wicklow, Ireland.

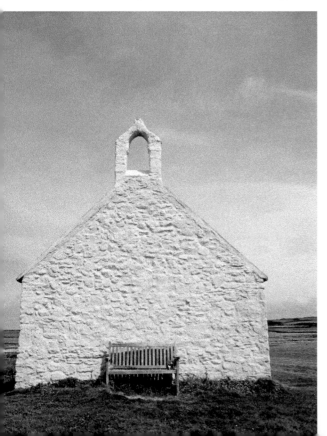

St Cwyfan's Church.

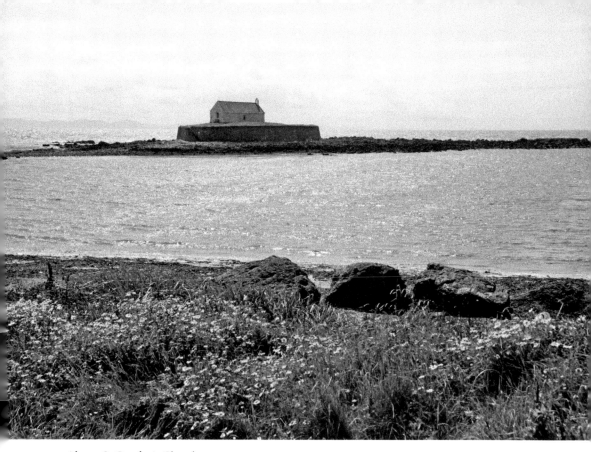

*Above*: St Cwyfan's Church.

*Below*: St Cwyfan's Church.

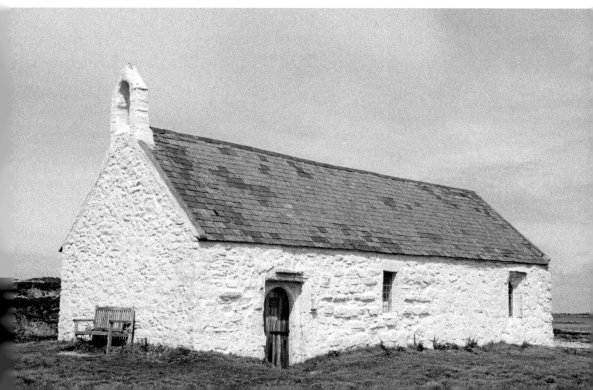

It may seem an odd and perilous place to build a church, but it originally stood at the end of a peninsula. Over the centuries the sea slowly eroded the coast enough that the peninsula was cut off, turning it into an island. A causeway was then built to the island to allow parishioners to get to the island at low tide. During high tides, or inclement weather, services were held in a room in the nearby house, Plas Llangwyfan, which was specially consecrated for the purpose.

The waves continued to eat away at the island until, in the late nineteenth century, some of the graves surrounding the church began to fall into the sea. At this time the church was also disused and roofless, having been replaced by a new church further inland. However, in 1893 local architect Harold Hughes, concerned for the fate of this evocative old church, raised money to construct a sea wall around the island and restore the building.

Although the church was initially built in the twelfth century, only a small portion of the south wall dates from this period. Most of the walls were rebuilt during a fourteenth-century reconstruction. In the early sixteenth century, an aisle was added to the north side, accessed through an arcade of three arches, but it was demolished in the early nineteenth century as the cliff edge eroded ever closer. The infilled arches can now be seen in the outer wall, after the old cement mortar was removed during refurbishment in 2006. This conservation work also involved limewashing the walls, making them very white, to the consternation of some locals who were used to the old grey appearance.

## 9. St Patrick's Church, Llanbadrig

Situated in one of the most scenic locations on Anglesey, St Patrick's Church is a place of peace and contemplation. The wind blows through your hair as you hear the cries of nesting seabirds on nearby Middle Mouse Island (Ynys Badrig). It was on that island that legend says St Patrick, the patron saint of Ireland, was shipwrecked.

Patrick made it to shore and found shelter in a cave with a good source of fresh water nearby. To give thanks for his survival, he founded a church here, probably around AD 440. The original church would have been a wooden one, but it was replaced by a stone building, the oldest part of which has been dated to the early fourteenth century. This makes it one of the oldest existing churches on Anglesey. It may have been extended in the early sixteenth century, making the chancel longer than seen in most similar churches.

The church was modified at various points in its history, including the addition of the porch in 1840, but in 1884 a major restoration took place. This was funded by Henry Stanley, 3rd Baron of Alderley, who owned the Penrhos estate near Holyhead. He had converted to Islam in midlife (becoming the first Muslim member of the House of Lords) and his plans for the restoration included Islamic-influenced designs. The stained-glass windows, instead of depicting biblical scenes and characters, were simple geometric designs. Tiles on the wall behind the altar also showed geometric or floral designs. There are some suggestions that he created these designs himself. Lord Stanley was also involved in the restoration of St Peter's Church in Newborough, where similar geometric designs were used.

One hundred years later restoration was again required, and £15,000 was raised to fund the work, finished in 1985. However, shortly afterwards arsonists struck and the church was badly damaged, particularly the roof. Fundraising again took place for repairs, and the church reopened on 24 May 1987.

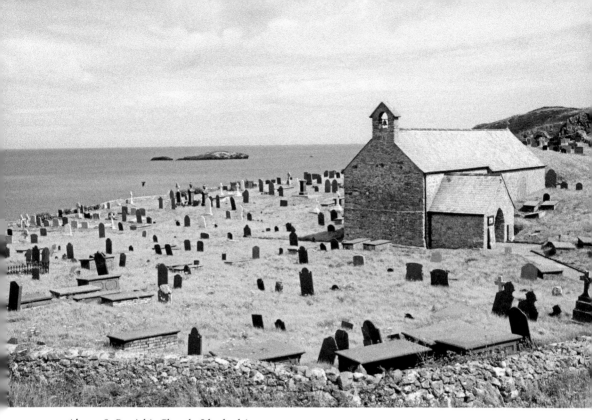

*Above*: St Patrick's Church, Llanbadrig.

*Below*: Inside St Patrick's Church, Llanbadrig.

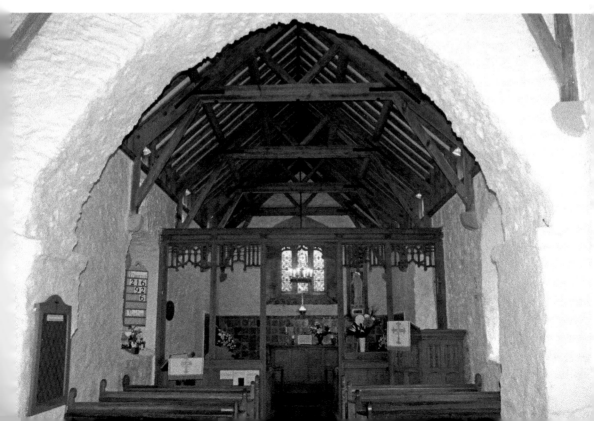

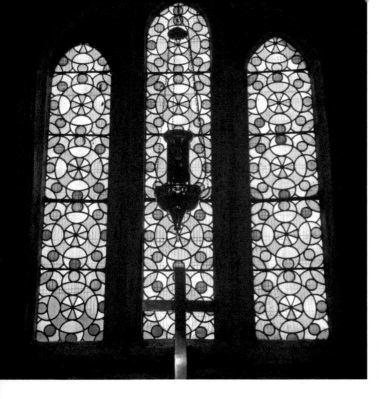

Islamic-influenced
stained-glass window,
St Patrick's Church.

The church is regularly attended by volunteers who are only too glad to show visitors around the most interesting features. A well-known visitor, His Holiness the Dalai Lama, pronounced this site 'the most peaceful spot on Earth'.

## 10. St Tysilio's, Church Island, Menai Bridge

Standing in the shadows of the Menai Strait bridges, St Tysilio's is one of the most familiar of the small churches on the island. It stands on an island in the Menai Strait, reached by a causeway, and along with the nearby woodlands and Belgian Promenade, is a popular route for strolls by local residents and tourists alike. A massive tree towers over the churchyard entrance but, although it looks like it might be a very ancient yew, it is actually a Monterey Cypress, just over 100 years old.

The church is dedicated to Tysilio, who was the son of Brochfael Ysgythrog, King of Powys. He fled his father's court to follow the religious life, eventually coming to Anglesey where he founded a hermitage on an island in the Menai Strait around AD 630. After seven years he moved on to become Abbot at Meifod, Powys, where he had started his religious training. He is thought by many to be the same person as St Suliac, who set up a religious centre in Brittany.

As with all early religious sites on Anglesey, the original buildings are long gone. Despite the plaque over the door saying 'St. Tysilio Built This Church 630AD', the current building actually dates to the early fifteenth century. Extensive restorations were done in the 1890s. The window at the east end of the church was installed at this time, and is a reproduction of the original fifteenth-century one. The original wooden trusses for the roof were preserved. The octagonal baptismal font originates from the fourteenth century.

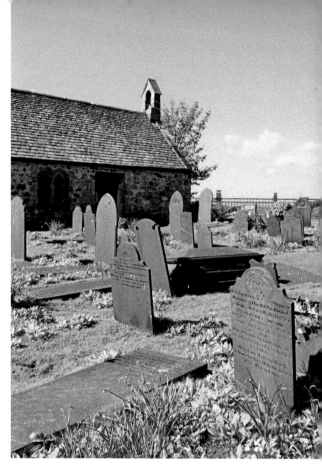

*Right*: St Tysilio's Church, with Britannia Bridge in the distance.

*Below*: St Tysilio's Church.

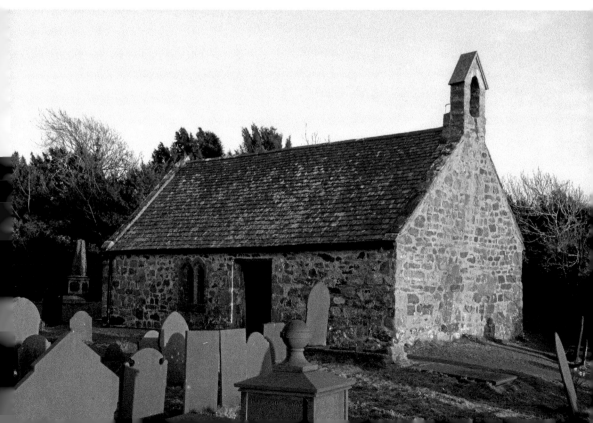

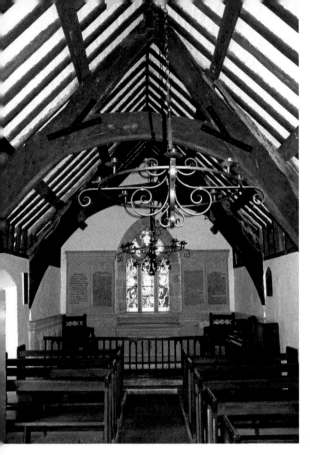

Inside St Tysilio's Church.

One unusual but attractive feature is the main door. The opening in the wall is rectangular, with a fitting door, but a massive oak frame with a round arched top has been fitted around the door.

The surrounding churchyard contains a number of interesting graves, including a tall broken pillar stone, under which rests John Hemingway, who was contracted to build the stonework of the nearby Britannia Bridge. On top of the hill stands the town war memorial, designed by well-known local architect Harold Hughes.

## 11. St Dwynwen Chapel, Llanddwyn

Llanddwyn Island (Ynys Llanddwyn) is a magical place. Located at the far end of a pleasant beach near Newborough Warren, this narrow finger of land (which is cut off from the mainland at high tide) is an ideal picnic site during fine weather, but also an exhilarating place when the winter winds blow.

The name Llanddwyn means 'The church of St Dwynwen'. She is the Welsh patron saint of lovers, making her the Welsh equivalent of St Valentine. Her feast day, 25 January, is celebrated by the Welsh with cards and flowers, just as is 14 February for St Valentine.

Dwynwen lived during the fifth century AD and was one of twenty-four daughters of St Brychan, a Welsh prince of Brycheiniog (Brecon). She fell in love with a young man named Maelon, but rejected his premarital advances. She prayed to be released from the unhappy love and dreamed that she was given a potion to do this. However, the potion turned Maelon

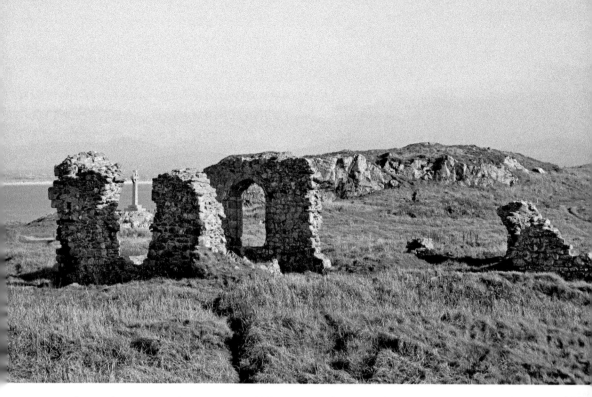

*Above*: The remains of
St Dwynwen's Chapel.

*Right*: Celtic cross erected on
Llanddwyn Island in the early
twentieth century.

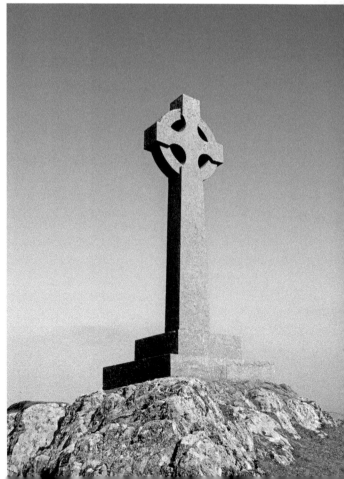

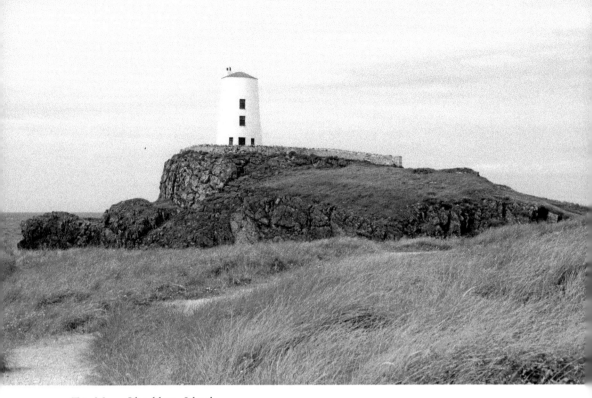

Tŵr Mawr, Llanddwyn Island.

to ice. She then prayed that she be granted three wishes: 1) that Maelon be revived, 2) that all true lovers find happiness and 3) that she should never again wish to be married. She then retreated to the solitude of Llanddwyn Island to follow the life of a hermit.

The island became a place of pilgrimage and by the fourteenth century was one of the richest churches on Anglesey. This funded a substantial chapel that was built in the sixteenth century on the site of Dwynwen's original chapel. Today only a few remnants of the walls are still standing, but two crosses remind visitors of the island's sacred status.

Llanddwyn Island is situated near the southern entrance to the Menai Strait. As a result it became important, as shipping of slate from the ports of Bangor, Caernarfon and Felinhelli increased. An unlit daybeacon called Tŵr Bach was built in the late eighteenth century at the tip of the island to provide guidance to ships heading for the Strait. Another tower, Tŵr Mawr, was built nearby in the early nineteenth century, and a light was placed on it in 1846. The older tower has now taken its place as the lighthouse after a modern light was placed on top in 1975.

## 12. St Gredifael's Church, Penmynydd

This building is similar to the many medieval churches that dot the Anglesey landscape, but its historical connections make it special. The nearby estate of Plas Penmynydd was founded in the thirteenth century by Ednyfed Fychan, who was lord steward to Llywelyn the Great, Prince of Gwynedd and ruler of much of Wales. Ednyfed's descendants include Henry Tudor, who later became King Henry VII of England, founder of the mighty Tudor dynasty.

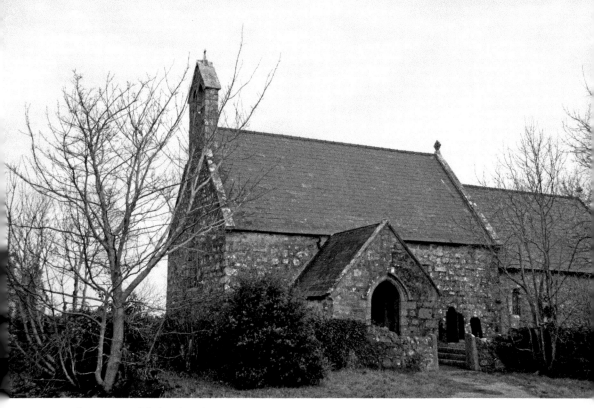

*Above*: St Gredifael's Church.

*Below*: Tomb of Gronw and Myfanwy Fychan in St Gredifael's Church.

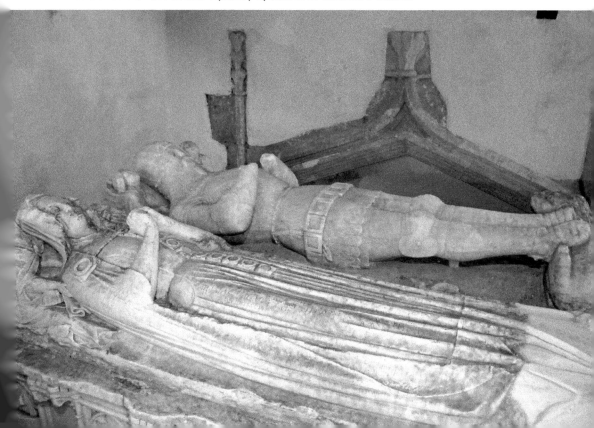

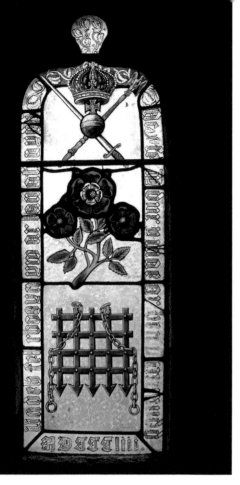

Tudor window, St Gredifael's Church.

In St Gredifael's Church is an impressive alabaster tomb topped with the effigies of a man in armour and a woman. This is Gronw Fychan, who died in 1382, and his wife Myfanwy. He was the great-great-great grandson of Ednyfed and the uncle of Owain Tudor. Owain became part of King Henry V's court and later married his widow, Katherine de Valois. This act gave their grandson Henry Tudor a claim to the English throne, which he exercised after defeating Richard III at Bosworth Field. Thus, the man in the tomb, Gronw Fychan, was Henry VII's great-granduncle.

The tomb itself is finely carved, down to the details of his moustache. It may have originally been at the monastery at Llanfaes, near Beaumaris, but was moved to Penmynydd after the Dissolution of the Monasteries. It may have been damaged at this time, and has suffered further as bits have been chipped off, in the belief that they had medicinal properties. Rain leaking through a skylight a few years ago damaged it even more, but funds have recently been raised to have it conserved.

This church also displays its Tudor connections with a stained-glass window incorporating symbols of the Tudor family. The Tudor Rose is present along with the English royal crown and other regalia. The motto reads 'UNDEB FEL RHOSYN YW AR LAN AFONYDD AC FEL TY DUR AR BEN Y MYNYDD', which translates from the Welsh as 'Unity is like a rose on a river bank, and like a House of Steel on the top of a mountain'. The phrase Ty Dur (House of Steel) refers to the name Tudor, and Ben y Mynydd (mountain top) is an alternative phrasing of Penmynydd.

Unfortunately, this window was smashed by vandals in 2007, but was quickly restored by the Friends of St Gredifael. The church is no longer regularly used, but is opened for special occasions by the Friends and the Diocese of Bangor.

## 13. Hafoty Medieval House, Llansadwrn

Set in an isolated spot near Llansadwrn, Hafoty is one of the oldest houses on Anglesey, and survives in remarkably pristine condition, with no signs of modernisation. It was probably built in the middle of the fifteenth century, and is known to have been owned by Thomas Norres in 1456. He was originally from West Derby in Lancashire, and was part of the English establishment settled in Beaumaris around the castle. It passed down through his family until 1511, when it was transferred to the Bulkeley family of Baron Hill, near Beaumaris, who own the freehold to this day.

The property was originally called Bodarddar, but after its transfer to the Bulkeleys it became known as Hafoty, which means 'summer house'. It was occupied by tenant farmers throughout the later centuries, eventually in the 1970s being passed to the care of the government Ministry of Works (now Cadw), who restored it.

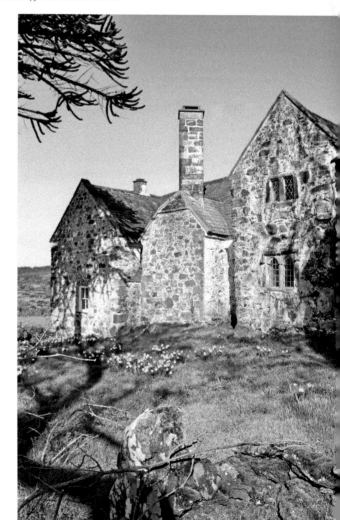

Hafoty Medieval House.

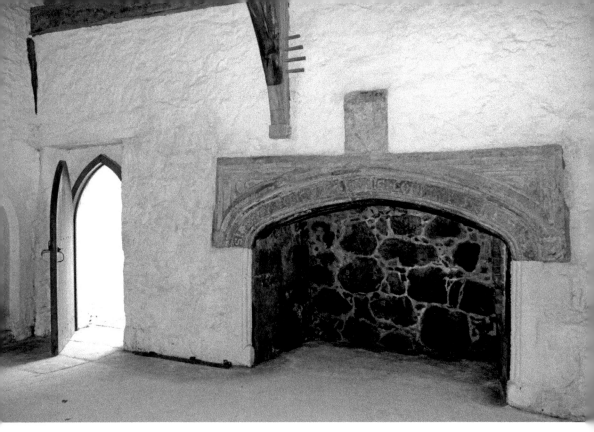

Great hall and fireplace of Hafoty Medieval House.

Hafoty is a type of high-status medieval dwelling known as a hall house. The main room is a large open hall, which would originally have had an open fire in the middle and a high table at one end. A two-storey wing at one end of the hall contained smaller rooms. The building was originally a half-timbered structure, but this apparently proved unstable, so it was reinforced with stone around the original timber.

A second wing was added at the other end after the acquisition by the Bulkeleys, giving the house its current H-shaped plan. The main beams and joists of the ceiling in this wing have been dated using dendrochronology, a process where comparison of the tree rings in a piece of timber can yield the date when the tree was growing. This shows that they came from trees cut down between 1509 and 1553. The central open hearth in the main hall was replaced by a fine fireplace, with a Tudor arch containing the inscription 'Si deus nobiscum, quis contra nos' ('If God is with us, who can be against us'), a Bulkeley family motto. Also carved in the arch are a Saracen's head and bull's heads, images associated with the family.

Although originally a high-status house, its later use as a simple farmhouse helped preserve the original features. Today the house can usually only be viewed from the outside, although Cadw do open it for guided tours on special Open Doors days.

## 14. David Hughes Grammar School, Beaumaris

Before the Tudor period education of young people was reserved for the very wealthy, who could afford to pay a private tutor or entrance fees to schools such as Eton and Winchester. However, the Reformation in the sixteenth century brought about an era of the creation

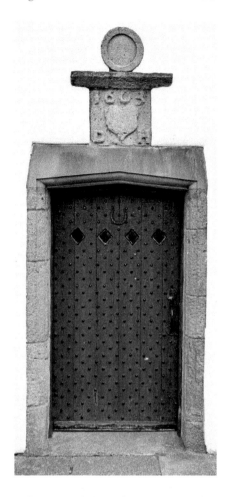

Doorway to David Hughes School, surmounted
by the foundation date and benefactor's initials.

of grammar schools, open to all no matter their wealth. One of the earliest ones in Wales,
Friar's School in Bangor, was founded in 1557 by an Anglesey-born lawyer, Geoffrey Glyn,
on the site of a Dominican Friary closed in the Dissolution of the Monasteries. This inspired
another prominent Anglesey-born lawyer, David Hughes.

Hughes was born in Llantrisant, graduated from Magdalen College, Oxford and
was admitted to Gray's Inn in London in 1583 as a law student. He afterwards moved
to Norfolk, where he became the steward of the manor of Woodrising around 1596. He
maintained contacts with his birthplace and, aware of the poverty and lack of educational
opportunities in Anglesey, was determined to remedy the situation.

After searching for a site for his new school, he purchased a tannery next to
Beaumaris Castle. Following alteration of the buildings it was opened as a grammar
school in 1603. Hughes died just a few years later, but in his will, dated 1609, he
left an endowment of several pieces of land, the proceeds of which would fund the
school as well as the almshouses on the outskirts of Beaumaris, which still stand on
the Pentraeth Road.

The school flourished through the centuries, primarily providing a classical education
to children of the gentry and merchant class, although classes in basic reading and writing
were also provided for children from poorer families. Many students were provided with

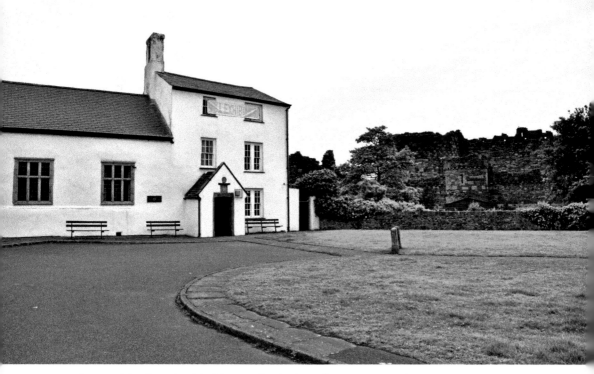

The David Hughes school building, in the shadow of Beaumaris Castle.

scholarships to attend to Oxford University. In 1895, the school and its endowment were transferred to the new Anglesey County governing body.

In 1953, Anglesey Council became one of the pioneers of the comprehensive school system in the UK, and David Hughes' grammar school was merged with the nearby secondary modern school. Increasing numbers of students meant that the school outgrew its buildings, so in 1963 a new comprehensive secondary school was built in Menai Bridge. The students, as well as the founder's name, were transferred to the new Ysgol David Hughes. The original building is now a community centre with an adjoining library.

## 15. Tudor Rose Shop, Beaumaris

Castle Street in Beaumaris probably has the finest collection of historic buildings on Anglesey. They range in age from the early nineteenth-century Bulkeley Hotel all the way back to the thirteenth-century castle and this building, the fifteenth-century half-timbered Tudor Rose.

The sign above the door says that this house was built around 1400, but the earliest positive date for it (through tree-ring analysis of the timbers) is around 1485. Like the Hafoty Medieval House, this is a hall house. These types of houses typically have a main hall composed of a large rectangular space, open to the roof, with a hearth in the centre, which would be the main public/entertaining area. They would also have wings at either end, built perpendicular to the hall, with smaller living and domestic rooms. In the case of the Tudor Rose, the side wing is the part that faces the street, with the hall in back oriented perpendicular to the road. It may also have once had a second perpendicular wing to the rear, but that has vanished.

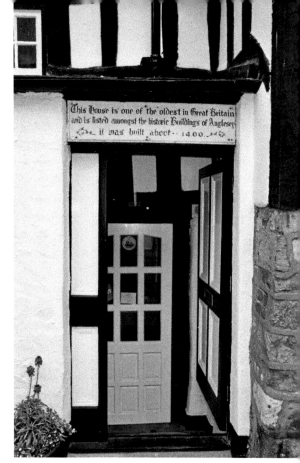

*Right*: Doorway to Tudor Rose Shop.

*Below*: Tudor Rose Shop.

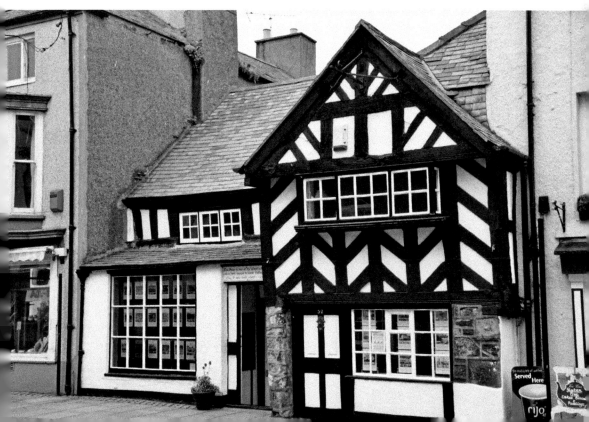

It has gone through many modifications over the centuries. The main hall is now divided into two stories by a floor added in the sixteenth century. This was preceded by the cladding of most of the timber walls with stone and the installation of a fireplace and chimney. In the following century some of the rooms were subdivided, and the current timbered frontage, with a two-storey gabled end at the right and a single-storey extension on the left, were added.

In the eighteenth and early nineteenth centuries, most of the buildings along Castle Street were 'Georgian-ified' – given fashionable Georgian frontages that hid older structures behind. However, the Tudor Rose survived this trend. By the 1930s it was recorded as being in poor condition, at risk of falling into ruin. However, during the Second World War it was bought by Belgian refugee and artist Hendrik Lek, who restored it and opened it as an antique shop. It was later a bookshop, artists' supply shop, and now an estate agent office.

## 16. George & Dragon Inn, Beaumaris

Inns and public houses have traditionally formed the heart of communities. As an ancient and well-preserved town, Beaumaris is blessed with a number of historic pubs, including the George and Dragon.

Sited close to the junction of the town's two main streets, a building was first recorded at this location in 1410, shortly after the two-year period when the royal town was occupied

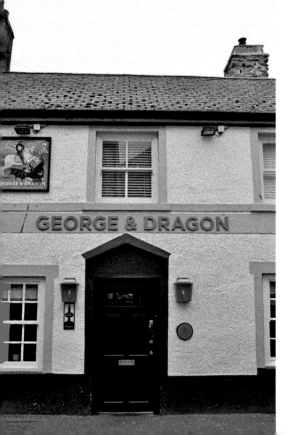

George & Dragon Inn.

by the forces of Owain Glyndŵr. However, that building was either replaced or substantially renovated a century later. The main beams and joists of the ceiling have been dated by tree rings, to show that it was built in 1541.

Written records indicate that the building was rebuilt in 1595, and one of the roof trusses bears the date 1610. The trusses at the gable end also have remnants of very interesting wall paintings, including horned devils and a cross with a bleeding heart. Below the painting are the Latin phrases 'PAX DEUS VOBIS', 'REQUIE DEFUGE', 'DEUS PROVIDEBIT' and 'NOSCE TE IPSUM', which mean 'The peace of God to you', 'Evade the rest', 'God will provide' and 'Know yourself'. Many fine houses of this era would have had either wall paintings or inscriptions, but this is unusual in having both.

The building was originally a town house, but by the eighteenth century had become an inn called the Red Lion, owned by John Lloyd and later by his daughter Janet, who passed it on to her half-sisters when she died in 1835. From around 1821 to 1849 it was run by Grace Lloyd and her husband, a mariner named John Williams. By this time it had been renamed the George & Dragon. John Evans was the publican for most of the second half of the nineteenth century and the early twentieth. Later in the twentieth century it passed through several hands, before being sold in 1968 to Robinson's Brewery, the current owners.

The pub was greatly refurbished inside in 2016, with the goal of showcasing the historic elements of the ancient building, including the great timber beams and an exposed section of the original daub and wattle wall.

George & Dragon Inn.

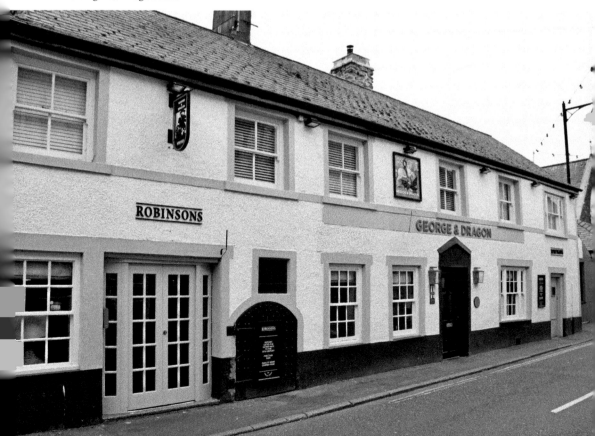

## 17. Swtan Thatched Cottage, Church Bay

A narrow lane from the village of Rhyd-wyn takes you to one of Anglesey's many pretty, secluded bays – Porth Swtan, or Church Bay. Here, alongside the sand, sea views, and cafe and seafood restaurant you can also step back in time. Here, alongside the car park, is a brightly whitewashed and thatch-roofed cottage called Swtan.

This tiny rural cottage was originally built in the sixteenth century and grew into a complex of outbuildings, including a grain store, henhouse, calf shed and cow byre, plus a vegetable garden. These, along with the few acres of land surrounding the cottage, provided everything needed to feed a smallholding family. In the early nineteenth century it was occupied by John Thomas and his family, but by 1851 it had passed to Owen Jones and his wife Jane. He ran the farm until his death in the 1890s, when it was taken over by his son Hugh. It passed down through the Jones family, eventually to the last tenant, Gwilym Jones.

By the 1960s the cottage was in very poor repair; the roof had collapsed and the walls crumbled. However, local people had a vision of restoring the cottage to its former glory and opening it as a folk museum. Money was raised through the local rural development agency Menter Môn and in 1998 skilled craftsmen and trainees descended on this hamlet. They turned the piles of fallen stones back into walls, erected new roofing timbers and rethatched the roof, all using traditional methods, and all finished in fourteen months.

A call then went out locally and further afield for donations of household goods and farming implements in order to restore the interiors to what they would have been like in

Swtan Thatched Cottage.

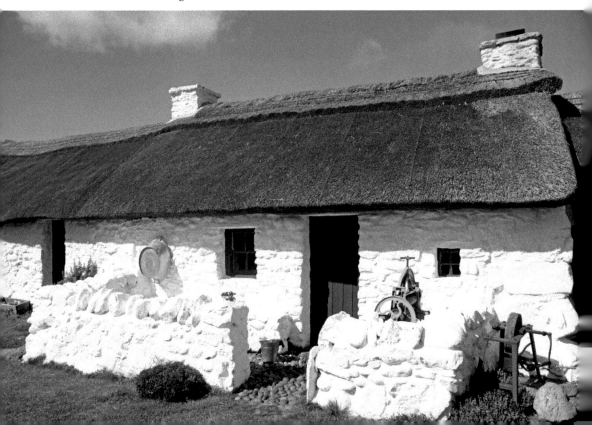

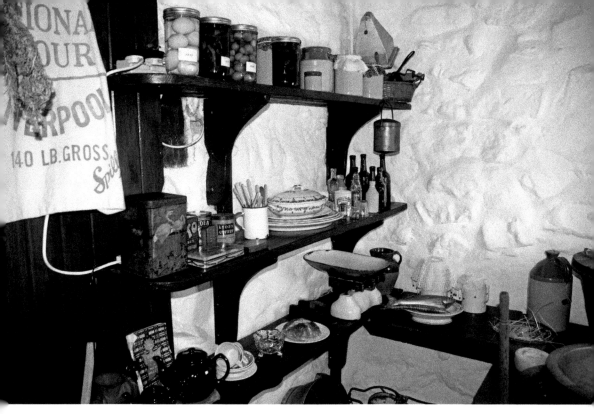

Inside Swtan Thatched Cottage.

the early twentieth century. It now again has a small but cosy living space, with fireplace, dining table and storage areas alongside a separate sleeping area on the ground floor, and another up a ladder in the loft. The outbuildings contain various farm tools as well as information displays. It is open to the public during the summer and is run by a volunteer-based charity, with one of the trustees being the last tenant, Gwilym Jones.

## 18. Beaumaris Courthouse

From its construction in the thirteenth century the castle in Beaumaris was the centre of power for the town and surrounding area. But, in the seventeenth century part of that power shifted across the road. The Beaumaris Courthouse was built in 1614, just opposite the castle, to be the seat of the judiciary of Anglesey. It is one of the oldest courthouses remaining in Britain. It was enlarged in the early nineteenth century with the addition of a grand jury room, prisoner holding cells, and other rooms. The interior was also refurbished, but it still retains much of its seventeenth-century character. The main courtroom has the original stone floor and roof trusses, and an iron railing separates the public benches from the boxes where the court proceedings were held.

It was here that the quarter sessions and assizes courts sat to try the more serious offenses passed on to them by the local justices of the peace. Those found guilty of crimes ranging from stealing corn or poaching to assault and murder were sentenced to punishments such as fines, public whipping or burning of the hand with a hot iron, as well as imprisonment, transportation and execution. Assizes courts continued being held here until 1971.

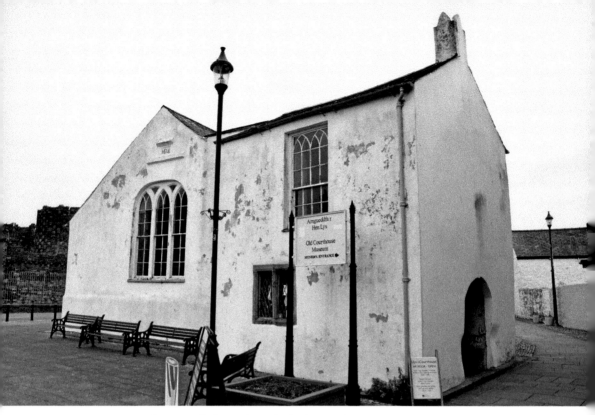

Beaumaris Courthouse, with the castle in the background.

Today it is open as a museum, although its future is currently uncertain because of local authority funding cuts. Visitors can stand in the dock facing the bewigged mannequins of the judge and barristers or sit in the jury benches, as well as view the prisoner holding cells and the grand jury room.

## 19. Beaumaris Gaol

Once convicted at the courthouse those sentenced to imprisonment were taken across town to Beaumaris Gaol. This imposing edifice was built in 1829, replacing an earlier one that was deemed inadequate after the Gaols Act of 1823. It was built by York architects Joseph Hansom & Edward Welch, who also designed the Bulkeley Hotel and Victoria Terrace. Joseph Hansom is best known as the creator of the Hansom Cab.

The 50-foot-high walls enclose a two-storey gaol building with cells for thirty prisoners, as well as a chapel, day rooms, and a punishment wing. The latter contains a treadmill, on which prisoners were forced to perform hard labour by turning a large wheel through walking on a continuous staircase. The treadmill at Beaumaris is one of the last still operational in Britain.

The ultimate punishment in any prison was execution, and two hangings occurred in Beaumaris. These took place from a doorway high up on the wall, overlooking the street below. William Griffiths was executed in 1830 for the attempted murder of his wife, and Richard Rowlands in 1862 for the murder of his father-in-law. Rowlands protested his innocence to the last, and according to legend, cursed the church clock he could see from the gallows, saying it would never show the correct time. The gaol also saw one escape.

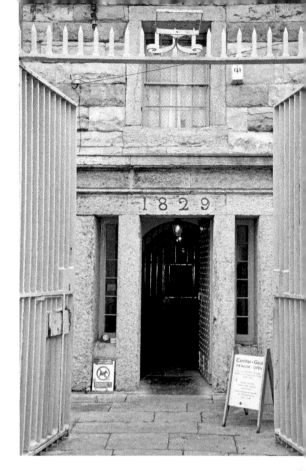

*Right*: The entrance to Beaumaris Gaol.

*Below*: The walls of Beaumaris Gaol.

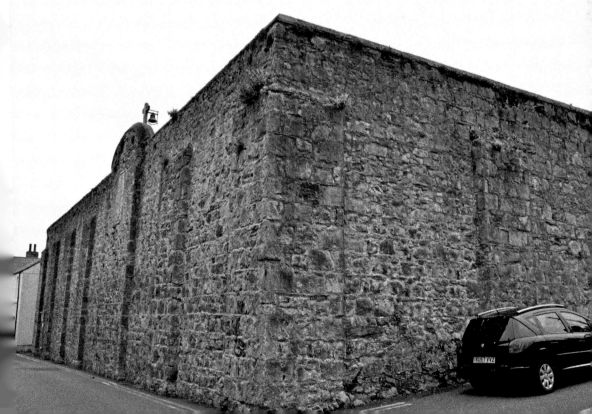

John Morris managed to get hold of a rope, which he then used to get over the walls, breaking his leg in the process. He was soon recaptured.

The prison had a relatively short life, closing in 1878. After this it became a police station and then, in 1975, the museum it is today. Like the Beaumaris Courthouse, financial constraints at the Anglesey Council mean its future is uncertain.

## 20. Hyfrydle Chapel, Holyhead

Throughout Wales the presence of the chapel and the nonconformist tradition was a huge influence on the culture as well as the built landscape. On Anglesey chapels dot the landscape, with at least one in any settlement of more than a few houses. Larger towns can have several, with Holyhead boasting sixteen chapels. Hyfrydle is the most prominent, and Anglesey's largest chapel.

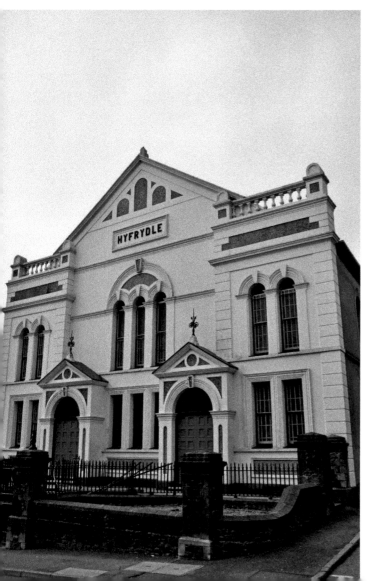

Hyfrydle Chapel.

In the eighteenth century the Calvinist Methodist followers in Holyhead met in private houses, usually on the outskirts of town, to avoid persecution. Nonconformists became more accepted by the early nineteenth century and in 1808 the congregation built a tiny chapel on Thomas Street in the town. It was soon enlarged, in 1815. The booming growth of the town after the completion of Telford's London–Holyhead road in 1826, and the later arrival of the railway in 1848, meant that this building was soon outgrown. The chapel was demolished and replaced in 1847, but even this wasn't enough; on one Sunday in 1851 it was recorded that over 1,600 people attended the two services. The chapel was again enlarged in 1856. In 1888, they purchased several neighbouring houses, demolished them and the old chapel, and built the current building.

With Holyhead being the port to Dublin, Hyfrydle Chapel developed an interesting connection to the Irish capital. An increasing number of Welsh sailors found themselves in Dublin looking for a place to worship while there. In 1838, Bethel, a Welsh chapel, was built on Talbot Street, near the port. It came under the jurisdiction of the *Henaduriaeth Môn* (the Anglesey 'Presbytery'), and Hyfrydle was the parent church. Ministers from Holyhead regularly travelled to Dublin to preach until the lead-up to the Second World War, when travel across the sea became dangerous. The chapel closed during the war and has since served several purposes, most recently as an internet café. It now has protected building status in Ireland.

The gradual but persistent decline of churches of all denominations means that many chapels in Holyhead have closed. The congregations of many of these have combined with that of Hyfrydle, so that this fine chapel remains open and well-used.

## 21. Capel Cildwrn, Llangefni

Capel Cildwrn is a simple but historic chapel. Founded in 1750, it was the first Baptist meeting place on Anglesey. Originally, the congregation met in a small domestic cottage called Tŷ Cildwrn. The name Cildwrn comes from the Welsh word for 'tip', and supposedly originated because the kind lady who lived there, selling eggs to the neighbours, would give sweets to the young children who came to collect the eggs. In 1781, the cottage was replaced with a purpose-built chapel, renamed Capel Cildwrn.

The year 1791 saw the arrival of Christmas Evans. Renowned for his powerful preaching style and vivid imagination, he is often considered one of the greatest preachers ever in Wales. Born on Christmas Day in 1766 near Llandysul, Ceredigion, he was the son of a shoemaker who died when Christmas was young. He grew up in hard circumstances, which included losing an eye in a fight. However, he was converted at a revival meeting, and the previously illiterate young man taught himself to read so as to study the Bible.

Evans soon moved on to preaching the gospel, and his talents began to be widely recognized. He was sent to North Wales and spent two years preaching on the Llŷn Peninsula. His reputation increased and he was asked to come to Anglesey to spread the Baptist cause there. His base was at Cildwrn, but he preached around the island and raised money for new chapels. After the death of his wife in 1823, and growing disagreements with some sections of the now greatly enlarged Baptist Church of Anglesey, he decided to return to South Wales. He preached in Caerphilly and Cardiff for several years, but then returned to North Wales, based in Caernarfon. He died in 1838, aged seventy-two.

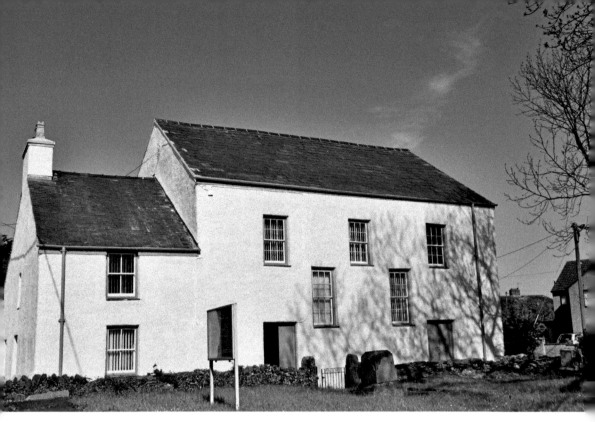

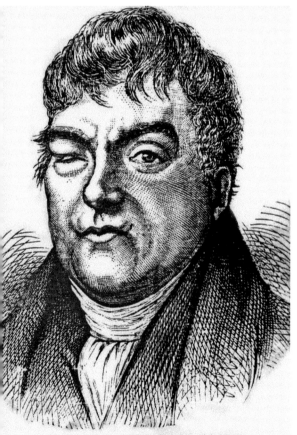

*Above*: Capel Cildwrn.

*Left*: Christmas Evans (1766–1838).

Y PARCH. CHRISTMAS EVANS,

Yr hwn a fu farw yn 72 mi oed.

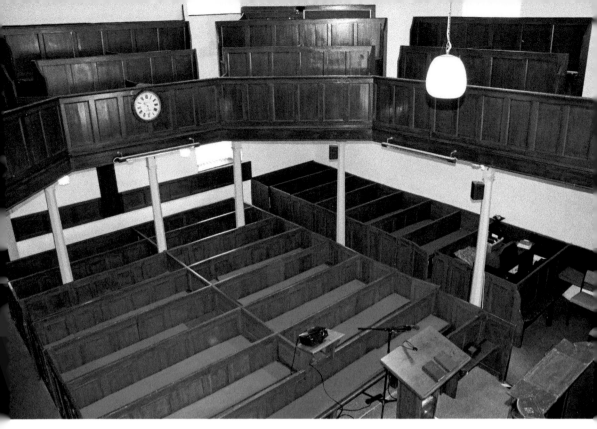

Interior of Capel Cildwrn.

This small chapel was modified a couple of times in the early 1800s, but in 1846–49 it was enlarged by raising the roof of two thirds of the building to provide a more spacious interior, with a larger gallery. At the end of the century the congregation decided to build a new larger chapel closer to the town centre – Capel Penuel. Capel Cildwrn was abandoned and disused for most of the twentieth century until it was renovated in the 1980s and reopened for services as an Evangelical church. It was again given a 'faith lift', as they called it, in 2017, with the exterior rendering and windows being replaced and painted.

## 22. Llynnon Windmill

Being an island on the west coast of Britain, Anglesey can sometimes be a very windy place, as the south-westerly winds blow in off the Atlantic and the Irish Sea. This wind proved a useful source of power, as windmills were built to supplement the watermills that were used to grind grain into flour. The earliest known windmill on Anglesey was built in 1303, but the boom years in construction were the mid-eighteenth and the nineteenth century. Almost fifty windmills are known to have been built, and thirty-one can still be seen today. Many are in ruins or are empty towers, while others have been converted into houses or, in one case, a mobile phone mast. But, on only one can the sails still be seen turning and the millstones grinding.

Llynnon Mill, near Llanddeusant, is the only working windmill in all of Wales. It was built in 1776, at a total cost of £529 11s (about £70,000 today). For much of its early

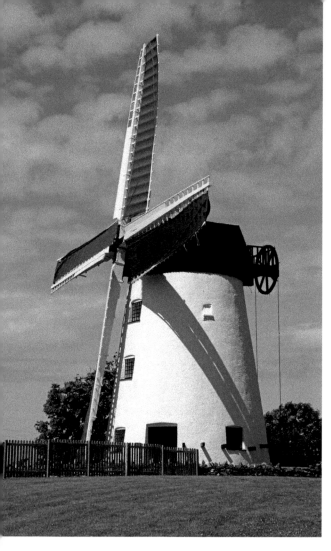

Llynnon Windmill.

life it was run by the miller Thomas Jones, who oversaw it until his death in 1846 at the age of ninety-one. It passed down through the generations to his sons and nephews until 1892, when it was taken over by Robert Rowlands, one of seven brothers who ran mills all around Anglesey. Milling was very much a family affair!

In 1918, a storm damaged the top of the mill so badly that the sails could no longer be turned to face into the wind. The mill could only be operated when the wind came from the south-west. It closed shortly afterwards, and began to slowly deteriorate. In 1954, another storm destroyed the top and sails.

In the 1970s Anglesey County Council was looking for a windmill to restore as a tourism and heritage attraction. Llynnon Mill was one of the few that still had all the machinery and millstones inside, and when it came on the market in 1978 the council purchased it for £10,000. A programme of restoration was begun, with the iron machinery being restored and new woodwork replacing all the old rotten timbers.

It was opened in 1984 and quickly became one of the iconic images and most popular attractions on the island. Guided tours let you see the mill in operation, grinding wholemeal flour, which can then be purchased in the neighbouring shop and tearoom.

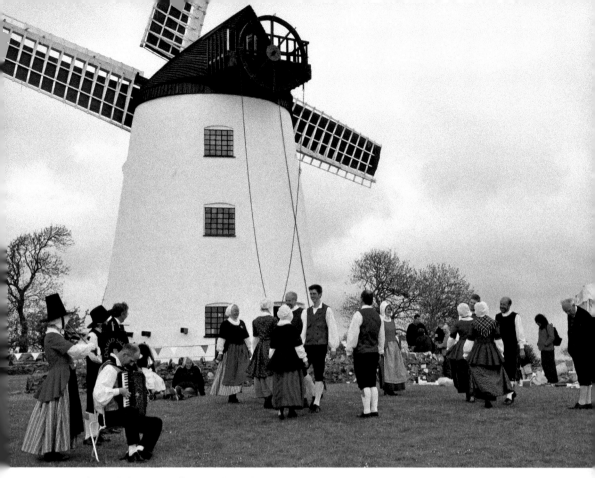

Traditional dancers perform at the mill during a special open day.

## 23. Melin Hywel Watermill, Llanddeusant

Just a short distance from Llynnon windmill is a lesser known but equally interesting watermill. Melin Hywel, also known locally as Felin Selar, is an impressive building, still containing the waterwheel, all machinery and millstones.

A watermill has stood on this site since 1352, when it is mentioned in the *Extent of Anglesey*, along with its miller, Hywel ap Rhys. At the time there were over sixty mills on Anglesey. The central part of the current building dates back to the early eighteenth century, when it was owned by the Williams family of well-known millers, who lived at the nearby Selar farm. In 1850, it was extended by the addition of the granary block and cart shed on one side and a storeroom on the other. The waterwheel was also enlarged and strengthened, the machinery was upgraded and a fourth pair of millstones was added.

In 1975, the building was fully repaired, the machinery refurbished and restored to working order. The restoration won a Conservation Award from the Royal Institution of Chartered Surveyors in 1978. It was used commercially to produce animal feed and was often open to the public for several years. However, recently, it has fallen into disuse and is showing signs of vandalism and deterioration.

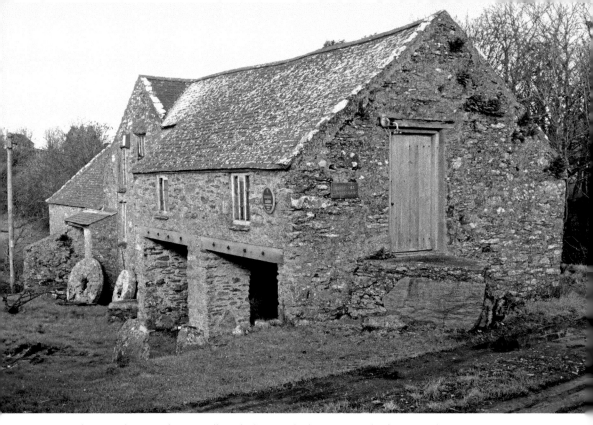

*Above*: Melin Hywel watermill, with the cart shed/granary in the foreground.

*Below*: The waterwheel, Melin Hywel.

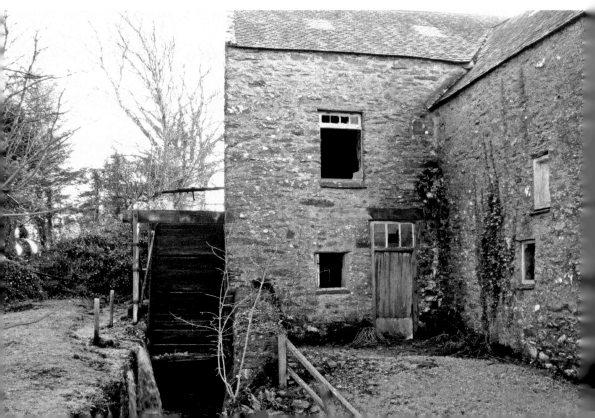

Although the machinery is still intact, the mill race has been diverted around the waterwheel to prevent damage. In 2016, it was advertised for sale at £175,000, and plans have been drawn up to convert it into a bed and breakfast business, with the old machinery forming a focus of the interior.

## 24. Melin y Bont Windmill, Ty Croes

The name of this converted windmill near Rhosneigr means 'Bridge Mill', named for the bridge over the nearby stream. It is also known as Melin Isaf ('lower mill') to distinguish it from the nearby Melin Ucaf ('upper mill').

The nearby stream is significant, as this mill was unusual in being driven by both wind and water. It was mostly a standard tower windmill, with sails driving a vertical shaft and the grinding millstones. But, in the lowest floor of the mill was a waterwheel, powered by water streaming through from a millpond. This connected to the same vertical shaft, with clutches that allowed the miller to choose between wind or water power. This gave it an advantage, as it could still keep working even if the wind was low.

It was built in 1825, on the site of an earlier medieval mill. At some point in its history a belt drive and connected rods were added from the main shaft into nearby buildings, where it also powered a butter churn and other farm machinery. It had a long working history and was powered by its dual source until 1930, when the sails were removed. It continued grinding with just its waterwheel for several more years. In 1973, a fire, started

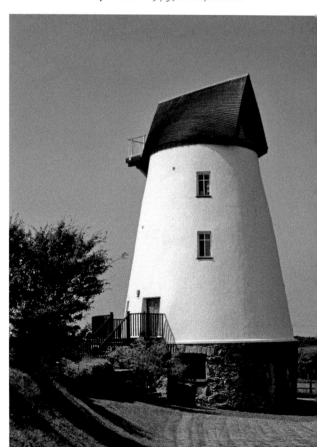

Melin y Bont Windmill today.

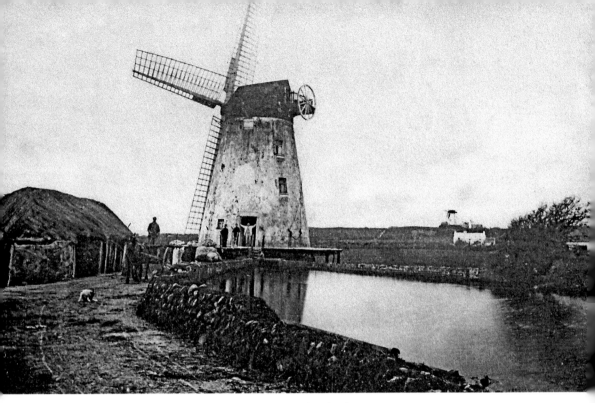

Melin y Bont Windmill in 1908, with Melin Ucaf in the distance.

by children playing with matches, gutted the tower, burning out all the floors and leaving the machinery at the bottom.

It lay derelict for thirty years until the owners, the Bodorgan Estate, decided to restore it. With the help of a £40,000 grant from CADW, the historic environment service of the Welsh government, it was restored and converted into living space, and is now rented out as a holiday home. The restoration work won builder Evan Owen the Conversion of the Year Award in 2007 from Anglesey's Building Control Awards.

## 25. Plas Newydd

In previous centuries the ownership of land, as well as commercial and political power, was held by a handful of prominent families, such as the Bulkeleys of Baron Hill and the Meyricks of Bodorgan. One of the largest estates was that controlled by the owners of Plas Newydd. This mansion, spectacularly overlooking the Menai Strait and the Snowdonia mountains, stands on the site of a house first recorded in 1470, owned by the Griffith family of Penrhyn, near Bangor.

The embryonic estate, which was originally known as Llwyn-y-Moel, passed down through the ages, expanding as it was transferred through marriages to the Bagnall and Bayley families. In 1784, it was inherited by Henry Bayley, who had succeeded to the title of Lord Paget, and later Earl of Uxbridge, through his mother's family. He soon undertook a major renovation of the old medieval house, with the result that almost nothing of the original building can be seen today. The work took place in two phases over thirty years, resulting in the mixed neoclassical and Gothic building of today.

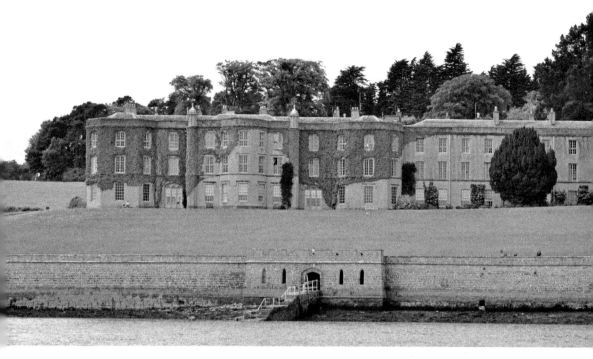

*Above*: The east front of Plas Newydd, seen from the Menai Strait.

*Right*: Statue of the 1st Marquess of Anglesey, on top of the Anglesey Column.

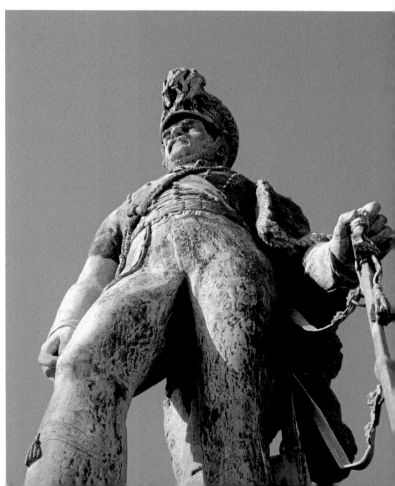

On Henry's death in 1812 the estate and titles passed to his son, Henry William Paget. The new 2nd Earl of Uxbridge was a distinguished military man, having risen to the rank of lieutenant-general by this time. He was a cavalry commander in the Battle of Waterloo in 1815, where he famously had his right leg shot off. Legend has it that he said to the Duke of Wellington, 'By God, sir, I've lost my leg!' to which Wellington replied, 'By God, sir, so you have!' Henry's heroism in the battle led to him being created the Marquess of Anglesey.

In 1898, the estate was inherited by Henry's great-great-grandson Henry Cyril Paget, the 5th Marquess. He is notable for his flamboyant lifestyle and profligate spending. A keen amateur dramatist, he had the chapel of Plas Newydd converted to a theatre, where he took the lead roles in the productions. He died early at the age of twenty-nine, having squandered all of the family wealth. His successor had to sell off their English properties to retain Plas Newydd.

In 1976, the 7th Marquess, a noted military historian, donated the house to the National Trust, who has turned it into one of the most popular tourist sites on Anglesey. The marquess continued living in private apartments in the mansion until his death in 2013.

## 26. Menai Strait Bridges

Although not strictly buildings, the bridges across the Menai Strait are iconic structures on Anglesey, a welcoming sight to those returning to the island after an absence.

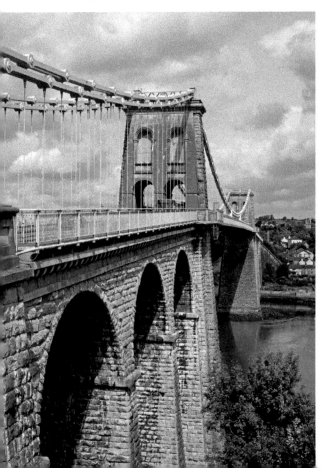

Menai Suspension Bridge.

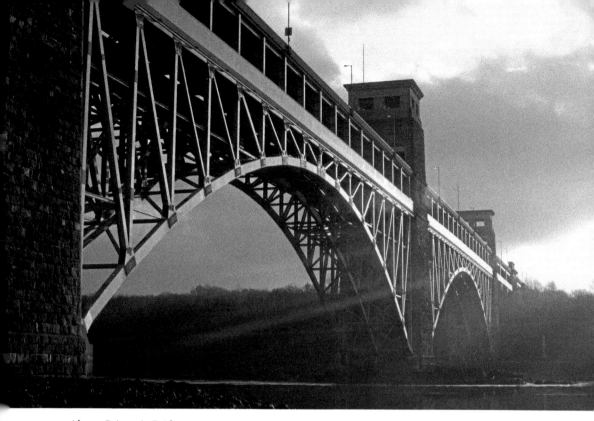

*Above*: Britannia Bridge.

*Below*: The Menai Strait bridges from the air.

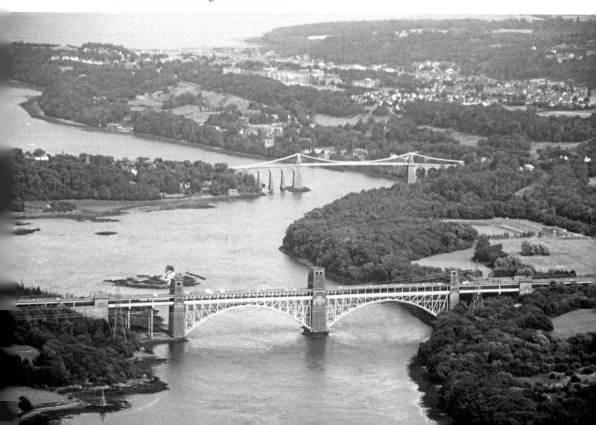

For centuries, ferries plied the Menai Strait, crossing to the Isle of Anglesey. However, the journey was often hazardous. The currents are tricky and numerous boats capsized or ran aground, often with loss of life. After the Act of Union in 1800, traffic to and from Ireland, through Holyhead, increased greatly. Plans were soon drawn up by Thomas Telford for ambitious improvements to the route from London to Holyhead, including a bridge over the Menai.

The bridge had to be 100 feet above the water level, to allow tall sailing ships to pass underneath. Telford needed a novel solution, and designed a suspension bridge, with sixteen massive chains holding up a road surface between the two towers. Although small suspension bridges had been built before, none approached the scale that Telford proposed for this one. When finished in 1826 it was the longest in the world.

The bridge has been modified over the years. Strong winds in 1839 damaged the wooden road deck, which was repaired and later replaced with a steel one. In the late 1930s the original iron chains were replaced with stronger steel ones, to support modern heavy vehicles.

Later in the nineteenth century, the railways began making their appearance, and the need for a rail bridge over the Menai was quickly recognised. Robert Stephenson took on the challenge of making a bridge long enough to cross the Strait and strong enough to carry heavy train carriages. He did this with a series of long iron tubes, rectangular in shape, through which the trains would travel. These were supported by three stone towers, one built on Britannia Rock in the middle of the strait. The Britannia Bridge was opened in 1850.

In 1970, the Britannia Bridge was seriously damaged by a fire, which left the tubes sagging and impassable. The bridge was rebuilt as a two-level one, with trains running on a lower deck and road traffic on an upper deck; steel arches were added to help support the extra weight. The doubling of road capacity across the Strait greatly eased traffic congestion, but by the twenty-first century ever-increasing vehicle use has meant the bridges are again congested at peak hours. For years plans have been mooted for a third bridge across the Menai. This may finally be built sometime in the near future.

## 27. Llanfairpwll Toll House

It is well known that Thomas Telford designed and oversaw the building of the great Menai Suspension Bridge in the 1820s, but it is less widely appreciated that he was also responsible for a major upgrade of the roads across North Wales leading to the bridge and the port of Holyhead. Narrow, winding and often muddy turnpikes were replaced by well-designed roads, with better drainage, a shorter distance and flatter topography, with less travelling up and down hills.

Telford's road has been further upgraded to the modern A5, but many of the features he designed and built are still prominent along its route. Most noticeable are the toll houses that dot its length. These are where travellers would be charged for using each section of the road (ranging in length from 2.5–10 miles) to fund their building costs and upkeep. The ones along the route from Shrewsbury to the Menai Strait were of a standard cross-shaped

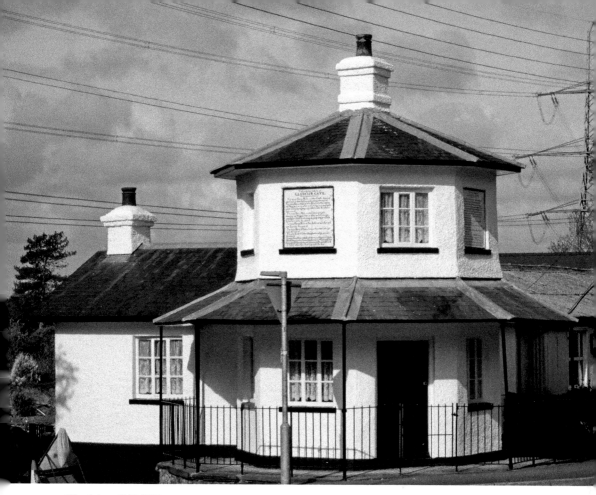

Llanfairpwll Toll House.

form, single-storey, and having a porch on the front with windows allowing views of the approaching traffic. But, the ones on Anglesey were a unique two-storey hexagonal structure.

There were five of these, four of which still exist. The one near Holyhead was moved away from the road and is now a thriving café near the Penrhos Country Park, while those at Caergeiliog and Gwalchmai are private residences. One once stood near the roundabout providing access to the A55 from the A5114 road from Llangefni, but is long gone. Finally, the best preserved one is in Llanfairpwll. It is next to the Women's Institute building (site of the first Women's Institute in Britain) and is now leased by them for use as a museum. It still retains the original toll boards showing the various charges.

The toll house not only provided an office for the toll keeper on the ground floor but also living space for the keeper and family in the upper storey and the two single-storey wings projecting out the back at right angles. They often had alternative employment while minding the toll gate. In 1841, the toll house occupier, William Jones, was a bookbinder while he and his family collected the tolls; later occupiers were labourers and letter carriers. The tolls across Anglesey were eventually abolished in 1895, when it was the last remaining toll road in Britain.

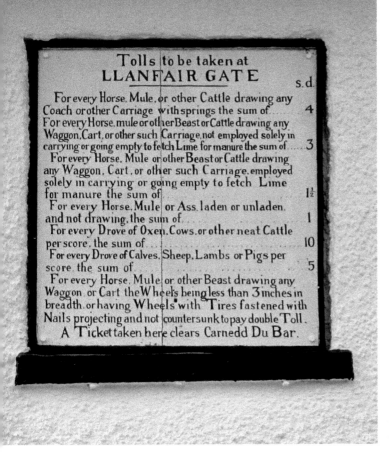

Toll board at Llanfairpwll Toll House.

## 28. Mona Inn

Before Thomas Telford built a new road across Anglesey, from his Menai Suspension Bridge to Holyhead, the old post road ran through Llangefni and Bodedern. It had several inns along the route, including the major coaching inn Gwyndy, in Llandrygarn. By building a completely new road, Telford also needed to provide accommodation for travellers, so he commissioned the building of a coaching inn halfway across, at Mona, around 1820. With the new road, travellers no longer passed or stayed at the old Gwyndy Inn, leading to its demise. The owner applied to Parliament, successfully, for compensation for loss of business. He also buttered his bread on both sides by moving to become the proprietor of the new Mona Inn!

Mona Inn was a large complex, with a double courtyard of buildings behind the main inn building. The main courtyard provided stables, carriage houses and accommodation for the grooms, while the second one, now derelict, was probably for agricultural purposes. The inn itself had large reception rooms at the front, seven bedrooms above and substantial cellars below. The smaller attached wing housed the kitchen and servants.

Modernization of travel soon caught up with Mona Inn. After thirty years, the railways had opened up across Anglesey and the Menai Strait, thus taking travellers straight to Holyhead. Mona Inn had become Mona Farm by 1851. Recently, attempts have been made to refurbish it but these have stalled. At the time of writing this book it is up for sale, with a guide price of £485.000.

*Right*: The Telford-designed milestones on Anglesey indicate the distance to Mona Inn.

*Below*: Mona Inn.

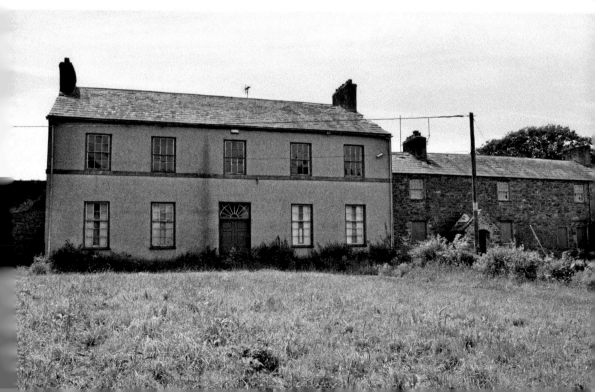

## 29. Llanfairpwllgwyngyllgogerychwyrndrobwllllantysiliogogogoch Railway Station

As the web of railways extended across Britain, and plans were developed for the Britannia Bridge rail crossing of the Menai Strait, a railway was constructed across Anglesey to the port of Holyhead. Seven stations were built along its route, including this one, the first after the bridge and the most famous. Its notoriety comes from its incredibly long name.

A medieval hamlet grew near the shore of the Menai Strait, named Pwllgwyngwll. Translated from Welsh this means 'the pool of the white hazels'. The church in this parish was dedicated to St Mary, so the Welsh term 'Llanfair' ('church of Mary') was often prefixed to the local name. It was sometimes shortened to Llanfairpwll.

During the Victorian rise in tourism, when many pleasure visitors started coming to Anglesey, a tailor from nearby Menai Bridge, Thomas Hughes, invented an extended version of the village name, probably as a family joke. It was soon picked up as a draw for tourists, inspiring many humorous postcards to send home from holidays.

The full invented name (with hyphens added to help in scanning the elements) is Llanfair-pwll-gwyn-gyll-gogerych-wyrn-drobwll-llantysilio-gogo-goch, which is usually translated to 'St Mary's Church in the Hollow of the White Hazel near a Rapid Whirlpool and the Church of St Tysilio near the Red Cave'. The closest approximation of the pronunciation for English speakers is 'Llan-vire-pooll-guin-gill-go-ger-u-queern-drob-ooll-llandus-ilio-gogo-goch'. The double L ('Ll') is pronounced sort of like a 'cl' in English, but with the tongue pressed to the top of the mouth, and the 'ch' at the end is a hard sound, rhyming with the Scottish 'loch'.

Railway platform sign, with the full name and pronunciation.

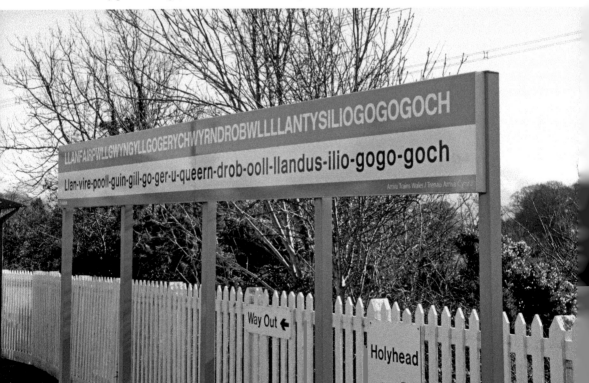

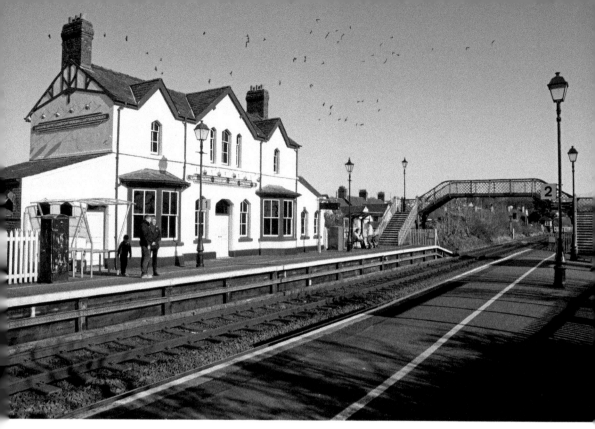

Llanfairpwll railway station.

The station building itself was opened in 1848, but suffered a fire in 1865 and needed to be rebuilt. As the station was originally opened two years before the Britannia Bridge, rail passengers from Holyhead had to take stage coaches across the Menai Suspension Bridge to Bangor. The same system was resurrected after the 1970 fire destroyed the railway across the Britannia Bridge. For another two years, until the bridge railway was reopened, passengers took coaches (powered by diesel rather than horses) across the Suspension Bridge.

The station building is not used for the railway any more and is currently empty, having recently been used as an art gallery.

## 3c. National School/Thomas Telford Centre, Menai Bridge

As the village of Porthaethwy grew into the town of Menai Bridge after the opening of the Menai Suspension Bridge, so too did the need for education of the children of all levels of society. One in the tradition of the nonconformist British school movement was being held in the Methodist chapel, but the Established Anglican church wished to have their own National School in the town.

The parish was outgrowing the tiny church of St Tysilio on Church Island, so the well-known architect Henry Kennedy was commissioned to draw up plans for a site including a new church and churchyard, school and headmaster's house closer to the town centre. Land with a commanding position overlooking the entrance to the Menai Bridge was donated by the Marquess of Anglesey, as was funding for the construction. The Menai Bridge National School was opened in 1854.

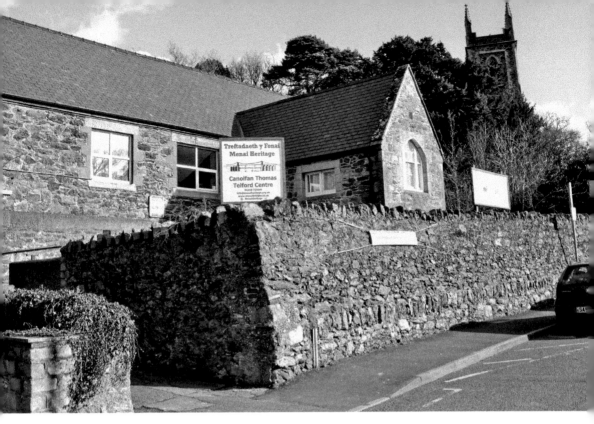

*Above*: National School/Thomas Telford Centre.

*Below*: Exhibition inside the Thomas Telford Centre.

Initially the school was a simple rectangle with a small porch on the front, but in 1878 an extension was built in the back to accommodate an infants' school. A cloakroom was added in 1896 and the front porch was extended in 1909. The syllabus of National Schools initially focused on study of the Bible and catechism, but in the early twentieth century it was expanded to cover other subjects like mathematics and literature.

The school was built to accommodate 200 pupils, but the competition from the new British School built in Dale Street in 1865 meant it was rarely full. A Council School was built in 1913 at the junction of the Pentraeth and Holyhead roads, further reducing numbers. In 1923, it was decided to merge the National and Council schools. On 29 March 1923 the students and teachers parcelled up all their belongings and, led by headmaster George Senogles, marched down the road to the new school, where they gave three cheers for the old school and three more for the new one.

The building continued in use as a parish hall for St Mary's Church until 2007, when it was purchased by the Menai Bridge Community Heritage Trust. They refurbished the building for use as a community centre and a museum dedicated to the Menai Strait Bridges and the history of the area.

## 31. Prince's Pier Warehouse, Menai Bridge

Before the Menai Suspension Bridge opened in 1826, the area that is now called Menai Bridge town was primarily common land, with a few scattered houses, plus a ferry house (later known as the Cambria inn), which served the ferries across the strait. The construction of the bridge saw the influx of large numbers of labourers, and with them the need for shops to supply groceries, hardware and other goods.

Prince's Pier warehouse.

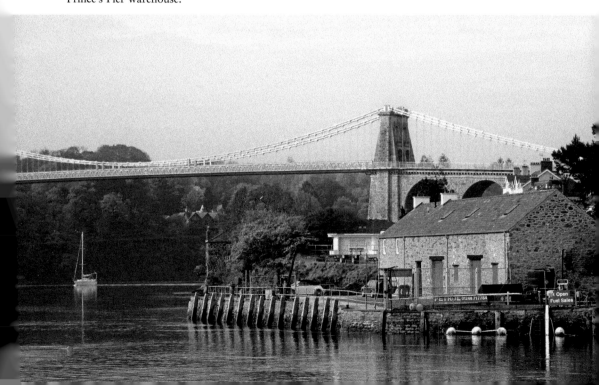

Exhibition inside the Prince's Pier warehouse.

Richard Davies, a shopkeeper from Llangefni, saw opportunities here for shipping in goods for the town. He leased land on the Menai Strait waterfront in 1828 from the Marquess of Anglesey and began building warehouses, first on Water Street, then closer to the water edge on a newly built wharf called Prince's Pier, between the two landing places Porth y Wrach and Porth Daniel. This latter warehouse, along with its adjoining piermaster's house, was probably built in the late 1840s or early 1850s.

As Richard and his son John expanded the business they began taking shares in locally built ships. These carried timber from North America, to be processed by a steam-powered sawmill that he also built nearby, as well as other goods. In 1843, they began their own fleet by purchasing a ship called *The Chieftain*, built in St John, New Brunswick, Canada. It brought timber from Quebec, then took slates from the North Wales quarries to New Orleans and other ports along the Gulf of Mexico, along with emigrants looking for a new life. They subsequently bought eleven more ships, which sailed as far away as Peru and Australia.

The use of the Prince's Pier warehouse declined over the decades and the warehouse had fallen into disrepair by the early twenty-first century. In 2014, the building was restored by Menter Môn and Menai Heritage, who plan to create a heritage centre here focused on the Menai Strait bridges.

## 32. Pier Gatehouse, Menai Bridge

Pleasure steamer ships started arriving in the Menai Strait from Liverpool in 1822 and quickly grew into a thriving business. These carried tourists along the North Wales coast, stopping at Bangor, Beaumaris and Menai Bridge. By the early 1900s up to 55,000 tourists arrived each year.

In Menai Bridge, the ships originally stopped at the old St George's Pier, but by the 1890s this simple stone-built pier was in poor repair and unable to cope with increasing numbers of passengers. Ships began using the nearby Prince's Pier Wharf.

In 1902, the local council, realising how much the area relied on tourism, purchased St George's Pier and began building a new one, more suited to the popular steamers. They also built a promenade, with ornate gates and the Pier Gatehouse, pictured here, at the entrance. A pavilion was also built to provide space for concerts and other entertainments. It was formally opened by David Lloyd George MP on 10 September 1904. The total cost was £16,500 (around £1.6 million in today's money).

This kiosk served as the ticket office for the steamers of the Liverpool & North Wales Shipping Co. It also charged a toll of a penny for admission to the promenade and pier. It continued in use until 1962, when the company closed and the last regular steamships sailed. The gatehouse was given Grade II Listed status in 1997 and was restored by the Menai Bridge & District Civic Society in 2000. It is now owned by the Isle of Anglesey County Council, leased by Menai Heritage, and has recently been opened as an ice-cream kiosk.

Tourists arriving at St George's Pier in 1905.

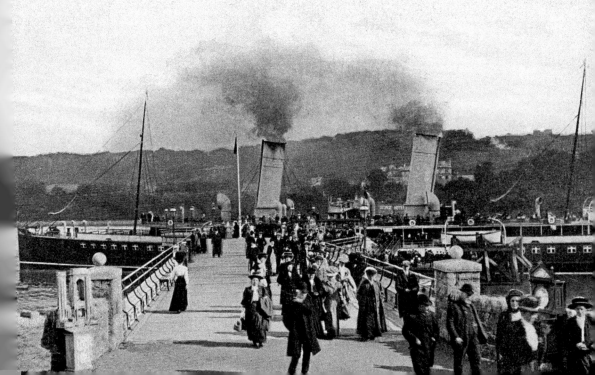

*arguerite," the Pier, Menai Bridge*

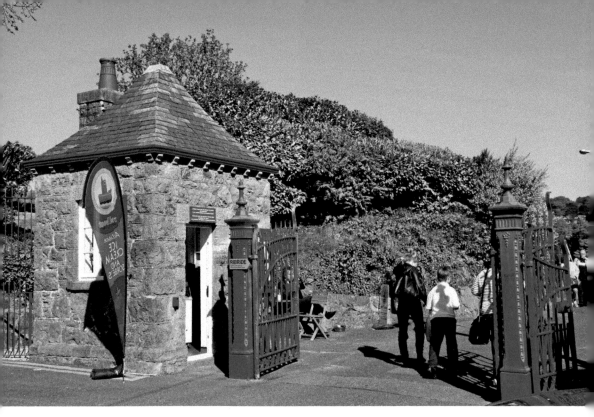

Pier Gatehouse and gates.

## 33. Parys Mountain Windmill

There are thirty-one old windmill towers on Anglesey, but this one is unique in several ways. It is the most visible, as it stands on top of Parys Mountain, one of the highest points on Anglesey, at an altitude of 138 meters (450 feet), and can be seen for miles around. It is also an industrial one, rather than agricultural. Instead of grinding grain, this windmill was used to pump water out of the copper mine on Parys Mountain.

Copper had been mined at a small-scale mine at Parys Mountain as far back as Roman times, but in the 1760s interest in the mineral wealth increased. In 1768, a rich vein of copper ore was found and within a few years it had become the world's largest copper mine.

At first the mine was opencast, as the ore was near the surface, but as that was mined out, and as mining techniques were improved, deep mining took over and shafts were sunk. These needed to have water removed, which was initially done with buckets and windlass. Steam engines were later employed, but the coal they required was expensive. It was decided to save costs by using the free supply of wind energy – a windmill was built in 1878. Unlike the other windmills on Anglesey, this one had five sails rather than the usual four.

A 1901 mining survey noted that this windmill was still working well at pumping. By this time deep mining had ended and the copper was being recovered through precipitation – water was pumped out of the mine and into ponds, where it evaporated, leaving behind the copper. Copper production further declined and the mine eventually closed in 1904. By 1929 the windmill was an empty, capless shell, which it remains to this day.

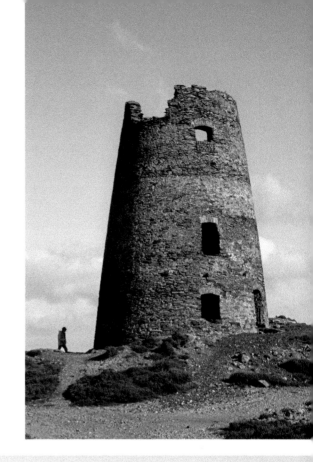

*Right*: Parys Mountain windmill tower.

*Below*: The main pit, Parys Mountain.

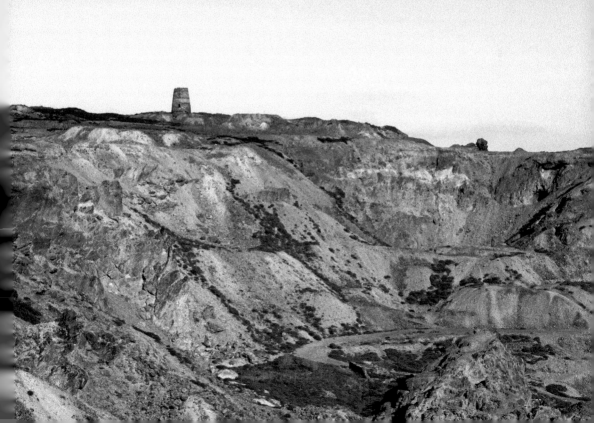

The mine area was once dotted with many other buildings, serving numerous purposes, but very little evidence of these is left. One that is still standing is the Pearl Engine House. Built in 1819 and situated at the eastern end of the mine, it housed a steam engine to pump water out of shafts in that area. The chimney of the engine house fell down in 1986, but in 2013 the Amlwch Industrial Heritage Trust, assisted by Heritage Lottery Fund money, rebuilt the chimney and refurbished the building.

## 34. Llanlleiana Porcelain Works

The coast around the Isle of Anglesey is magnificently scenic, with wild cliffs, rolling hills and sandy bays. Many sections can be quite isolated, with just the occasional visitor. But even at these places you can stumble across remnants of Anglesey's working past. A couple of miles north-east of Cemaes the Anglesey Coastal Path brings you over a ridge and down to Porth Llanlleiana, where you find the crumbling remains of a factory.

The buildings here are what's left of a porcelain works. A seam of good quality china clay was discovered on the side of this valley in the nineteenth century. The proximity of a sandy bay provided a transport link, so a works was built here to quarry and process the clay. The larger buildings housed the offices, workshops and furnaces where they would produce and fire the porcelain objects, which could then be shipped directly out to their markets. The chimney for the furnaces was set well up the hillside, connected to the buildings by a tunnel, so that fumes would be kept away from the workers. The works closed around 1920 after being damaged in a fire.

This valley and bay has a long history before the porcelain works. The hill above the main works is Dinas Gynfor, the site of an Iron-Age hill fort. The site is well defended,

The main works building and chimney of Llanlleiana porcelain works.

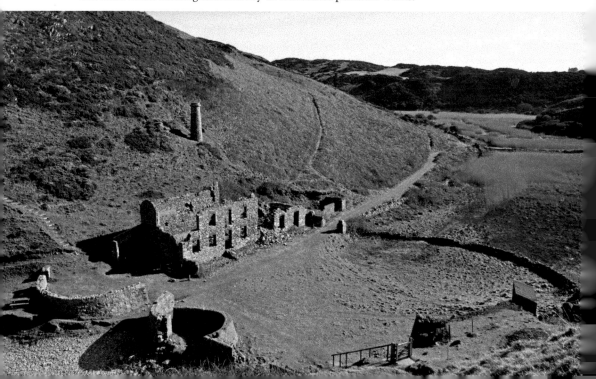

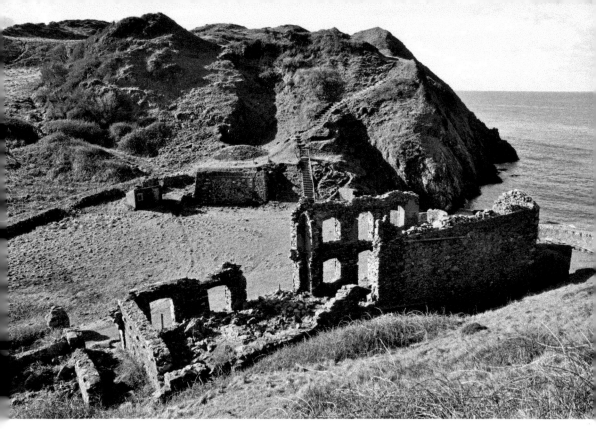

Looking across the valley to the Llanlleiana clay quarry.

being on a peninsula with cliffs and sea on three sides, and a steep slope down to a marshy valley on the fourth. The remains of various defensive walls and ditches can be detected, but no excavations have taken place here, so nothing is known about the living structures or the people. Today the hilltop is the site of a small summer house overlooking the sea, which was built in 1901 to commemorate the coronation of Edward VII.

Across the valley, above the clay quarry, is a place that is marked on old Ordnance Survey maps as the 'Site of Llanlleiana', the location of an old church. Some reports say that the ruins and gravestones were visible in the mid-nineteenth century, but they are now long gone. The Welsh word *lleian* means 'nun', so it is thought that Llanlleiana was a nunnery, although there are no historical records to support the presence of a nunnery here (or indeed anywhere else in North Wales).

## 35. Ship Inn, Red Wharf Bay

Red Wharf Bay is the largest bay on Anglesey, with over 10 square miles of sand exposed at low tides. It is known as *Traeth Coch* in Welsh ('Red Beach'), and the 'red' in both names is said to come from a battle against the Vikings that occurred here in 1170, leaving the sands soaked in blood.

This settlement on the edge of the bay was a thriving port and shipbuilding area throughout the eighteenth and nineteenth centuries, although records of it being a port stretch back to the early fifteenth century. Ships brought in coal and other supplies, while

*Left*: View from the Ship Inn.

*Below*: The Ship Inn.

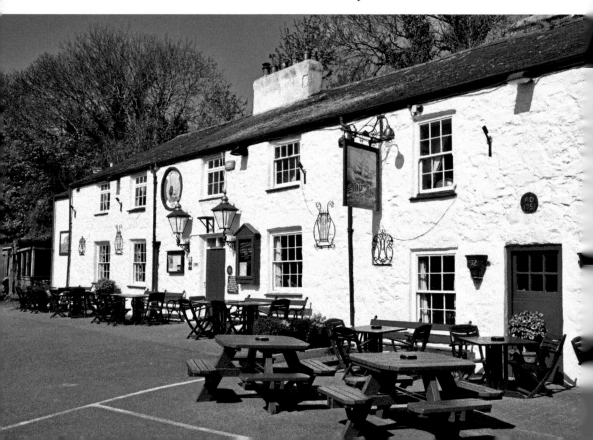

grain and stone from local quarries were shipped out. A large warehouse once stood where the car park is now, in which the goods would be stored.

The Ship Inn, built in the early nineteenth century, provided vital sustenance to the sailors and workers, as it does today for tourists and locals. Originally called the Little Quay, then later the Old Quay, it had been renamed the Ship Inn by 1881. The inn initially occupied just the left two thirds of the building, with the rest being a cottage (built in 1751, according to a plaque over the door).

The pub, which has been run by the Kenneally family since 1971, is a Grade II-listed building with many original features, including the windows and slab floors. The décor inside evokes the old maritime days, with ships lanterns, Toby jugs, and nautical bric-a-brac lining the walls.

## 36. Holyhead Customs House and Harbourmaster's Office

After the Union of Britain and Ireland in 1801, travel to Dublin from London increased dramatically. Thomas Telford drew up plans to improve the roads to ease the land journey, but the existing harbour at Holyhead was ill-suited, being just a tidal creek. The great engineer John Rennie was commissioned to improve the harbour to accommodate not only the old sailing ships, but the new packet steamers as well.

Holyhead Customs House (left) and Harbourmaster's Office.

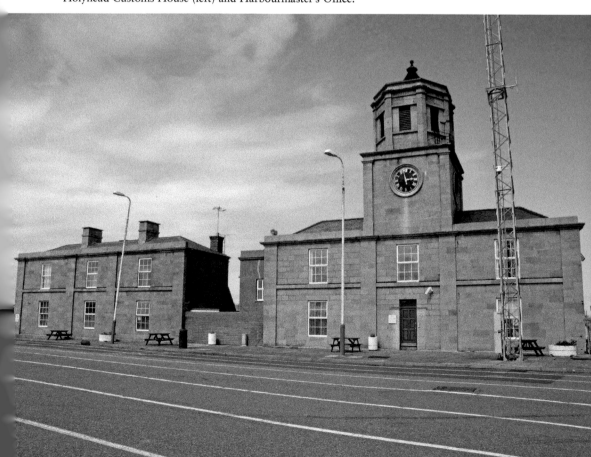

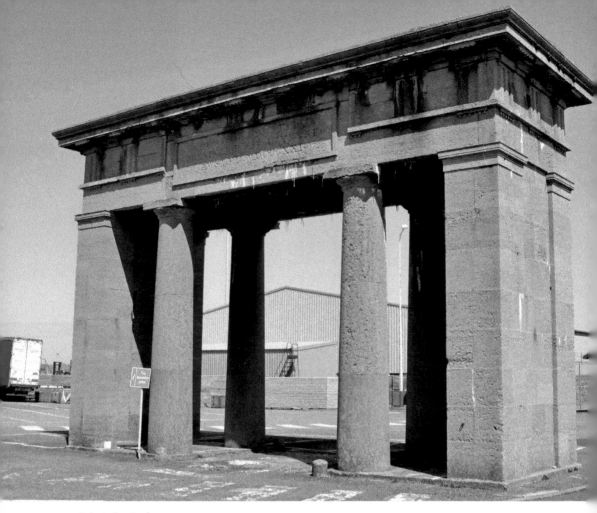

Admiralty Arch.

Rennie's plan was to create a sheltered area of the inner harbour by building a stone pier extending from Salt Island, plus a bridge between the island and the town. Work on Admiralty Pier began in 1810 and was mostly complete in 1821, the year of Rennie's death. Telford took over responsibility to finish the harbour, which included this handsome pair of matching buildings.

To the left is the Customs House, a building where government officials levied duty on imported goods and generally monitored trade through the port. On the right, with the clock tower, is the Harbourmaster's Office, the heart of the port's operations. Both were built of local Mona Marble.

While the pier was being completed King George IV's ship landed at Holyhead on the way to Ireland. To commemorate the visit a triumphal arch was commissioned, designed by Thomas Harrison. Admiralty Arch was unveiled in 1824 and is traditionally considered to mark the end of the London–Holyhead Road, which begins at London's Marble Arch. The buildings and arch are now generally only viewable by travellers boarding the ferries to Ireland. However, there have recently been calls to move the arch to a more prominent position in Holyhead.

## 37. Holyhead Lifeboat Station/Maritime Museum

Being an island surrounded by the sea, much of the Anglesey coast has strong maritime connections. In particular, there are currently four lifeboat stations around the coast, staffed by volunteers who fearlessly rescue those in danger at sea.

A lifeboat was first stationed in Holyhead in 1829, shortly after the foundation of the Royal National Lifeboat Institution (RNLI). In the same year, the first of many RNLI medals was awarded to members of the Holyhead lifeboat crew, when Thomas Hughes was honoured for leading the rescue of twenty-four people from the brigs *Harlequin* and *Fame*, which had foundered on rocks in a gale.

In 1858, this purpose-built station was opened to house the lifeboat. It is probably the oldest lifeboat station in Wales. As newer and larger lifeboats were donated to the station, the building had to be extended and slipways/landing stages modified. Eventually in 1949 a new lifeboat station was built on Salt Island, which was later superseded by the current building at the western end of Newry Beach. The original lifeboat building was used for various purposes, but eventually became the Beach Café, then the Zodiac Restaurant. It was given Grade II-listed building status in 1994.

In 1982, a group of local maritime enthusiasts set up a temporary exhibition about Holyhead's connection with the sea. In 1986, they leased the redundant St Elbod's Church to house the exhibition in a more permanent location. When that lease expired they were offered the old lifeboat station by the owners of the harbour, Stena Line. Heritage Lottery Fund money supported the renovation of the building and in 1998 the Holyhead Maritime Museum was opened. It is now a thriving visitor attraction telling the story of area's maritime history, with a special exhibition about the two world wars housed in the nearby air-raid shelter.

Holyhead Lifeboat Station/Maritime Museum.

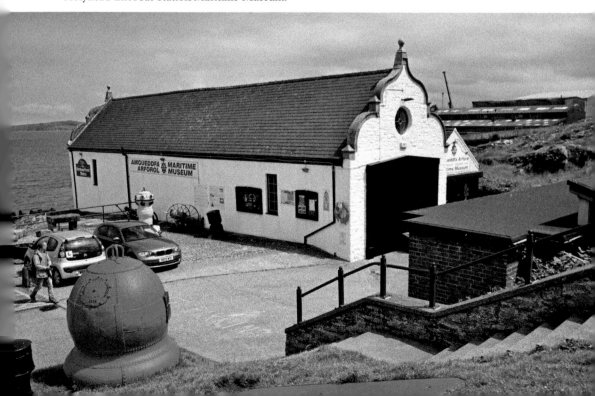

## 38. South Stack Lighthouse

Anglesey is an island decorated with dramatic cliffs, isolated coves and sandy beaches, which overlook the Irish Sea and its busy shipping lanes. Its rocks pose a threat to the vessels sailing by, so a number of lighthouses have been built around the island. The most famous and picturesque of these is South Stack, near Holyhead.

The lighthouse is built on Ynys Lawd, a small rocky island just off the edge of Holy Island, which itself is an island just barely separate from the main part of Anglesey. To reach it you need to descend a switchback stairway running down the cliff face, over 400 steps down (and 400 back up). At the bottom a bridge carries the visitor over a chasm to the island.

The need for a lighthouse on this part of the Anglesey coast was recognized as far back as 1645 when a petition was sent to King Charles I asking for a lighthouse to be built on South Stack. This request was refused, however, as being an unjustified expense for shipowners. But, in 1808 plans were finally approved, and the lighthouse was completed in a remarkable nine months.

The original lighthouse produced its light by using twenty-one oil lamps with reflectors, on a three-sided rotating base. It took six minutes for one rotation, so the lighthouse gave a flash from one of its three sides every two minutes. This light, shone from 200 feet above the sea level, could be seen up to 30 miles away in the best weather conditions. For less than ideal conditions, other signals such as a foghorn and a lower light close to the sea were added over the following decades. The main light too was upgraded several times; it

South Stack Lighthouse.

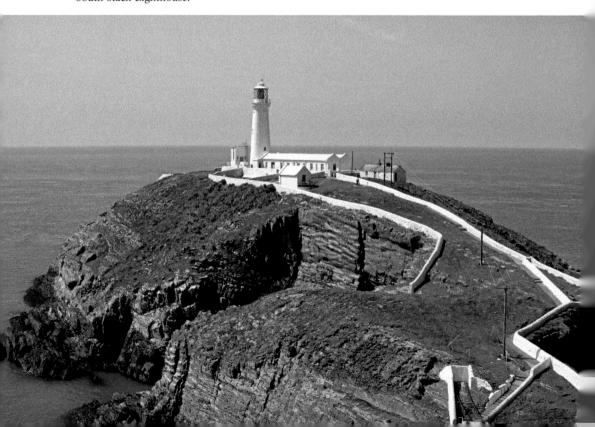

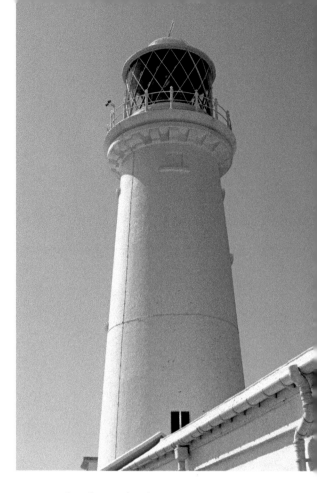

South Stack Lighthouse.

was electrified in 1938, and automated in 1984, removing the need to have a permanent lighthouse keeper.

In the 1990s the county council leased the island from the lighthouse authority Trinity House in order to open it to the public. The bridge to the island needed to be replaced, as the old one was in poor repair. In 1997, it was opened and became one of the island's most popular attractions. It is surrounded by an RSPB nature reserve where, during the spring and summer, you can see thousands of seabirds nesting on the cliffs.

## 39. Skinner's Monument and Stanley House, Holyhead

Flanking Holyhead harbour are two structures connected to one of the town's most eminent seamen. On a hilltop overlooking the entrance to the ferry port is an obelisk called Captain Skinner's monument. Across the harbour, next to the church, is Stanley House, once the home of Captain Skinner.

John Macgregor Skinner was born in 1761 in Perth Amboy, in the North American colony of New Jersey. As a young child he lost an eye in an accident while playing with darts. However, that did not prevent him from pursuing and achieving a distinguished naval career. He joined the Royal Navy in 1776, in the lead-up to the American Revolution. The fourteen-year-old started as a captain's servant on the *HMS Phoenix*. Unfortunately, just eight months later he had his arm shot off during a skirmish with the American rebels.

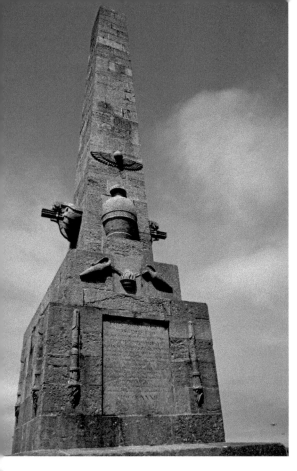

*Left*: Skinner's Monument.

*Below*: Stanley House.

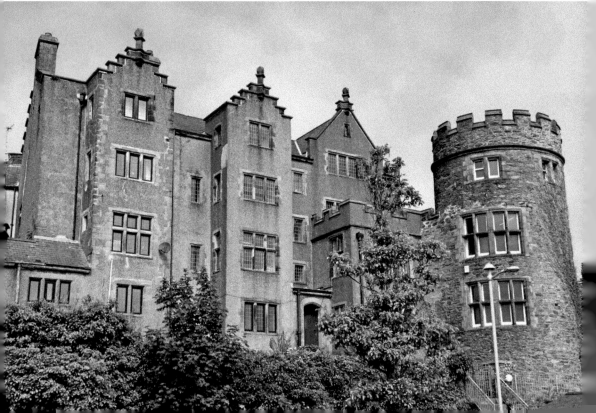

Even this did not deter Skinner, and he continued on in the navy, rising to the rank of lieutenant, serving in the West Indies and the Mediterranean. In 1793, he was tempted away from the navy to a more lucrative career as the master of post office packet-ships. Six years later he was posted to Holyhead, to take command of the packet-ship *Leicester*, sailing to Dublin. During his time there he campaigned vigorously for improvements to the services and the conditions on board.

He spent thirty-three years in Holyhead and became well known and loved for his generosity and goodwill. But, he tragically died in 1832 when he was swept overboard from the ship *Escape*. A public subscription raised money to erect the monument to his memory.

In his later years, Captain Skinner lived in Stanley House, overlooking the harbour. The house was built around 1810 by the Stanley family of Penrhos, the major landowners around Holyhead. It is thought that it was built specifically for Skinner, and features in a painting on display at the Holyhead Maritime Museum, which depicts his friends and grateful townspeople gathered outside the house. It is now a Grade II-listed building and has been used as a solicitor's office for many years.

## 40. Prichard Jones Institute, Newborough

In 1841, a young boy named John Jones was born on a farm near Newborough. At the age of fourteen he was apprenticed to a draper in Caernarfon. He later worked in Pwllheli and Bangor, then in 1872, got the chance of a lifetime by getting a position with Dickins,

Prichard Jones Institute.

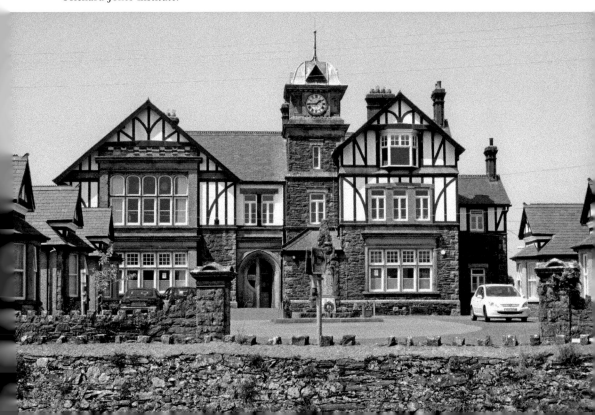

Smith & Stevens on Regent Street, London. He rose through the ranks to eventually become co-owner of the store, which was then renamed Dickins & Jones. It was considered one of the largest and finest department stores in London. By this time he had changed his surname to Prichard-Jones and in 1910 was made a baronet.

Although fabulously wealthy, his humble background meant he was also concerned for the common man. He supported workers' welfare and introduced profit-sharing schemes for his employees. He was also a benefactor of the university in Bangor, where a performance hall is named after him. However, he never forgot his home village and in 1902 commissioned the building of a community centre for Newborough.

The Prichard Jones Institute, as it was called, opened in 1905. It provides a free library alongside meeting, reading and recreation rooms. It is also flanked by six small three-room cottages, built to house needy elderly people of the village, who also receive a pension.

By the early twenty-first century the building was beginning to fall into disrepair. In 2006, it was selected as one of three historic properties to compete in the BBC TV show *Restoration*, which would select one to restore with the help of lottery funds. Unfortunately, the Prichard Jones Institute lost. However, its supporters went on to raise £650,000 to fund a full refurbishment, which was completed in 2008.

## 41. Cloth Hall, Pentraeth

Today most of the smaller villages around Anglesey have few or no shops, but several decades ago most would be able to boast at least a few grocers, butchers and other shops.

Cloth Hall, Pentraeth.

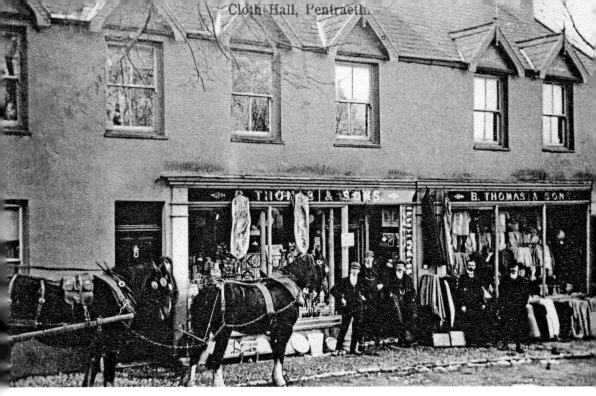

Cloth Hall in 1906.

The village of Pentraeth had several shops, but the king was Cloth Hall. This large shop, established in the 1870s, was a proper emporium, advertising itself as a 'grocer, tea dealer, iron monger, flour and corn dealer, milliner, outfitter, linen and woollen draper, bootseller and agent for all kinds of implements'. It even published its own postcards, pictured here.

The founder of Cloth Hall was Benjamin Thomas. He was born in Rhoscefnhir, near Pentraeth, in 1841, son of tailor Hugh Thomas. He married Margaret and started his family and his own tailoring business in Hen Shop. In the 1870s he expanded into the current Cloth Hall building.

Benjamin died in 1899 and the shop was taken over by his two sons, Hugh and Thomas, assisted by Grace Parry, milliner, and Annie Roberts, dressmaker. His wife Margaret and youngest son David moved to Fron Goch, a farm a short distance away that Benjamin had bought shortly before his death, and where some of his descendants still live.

The store was run successfully by the Thomas family through the 1960s, surviving a fire in 1959 that destroyed the first floor of the western end, which was never rebuilt. It later became a general grocery store, then a pine furniture shop. It now sells carpet and flooring.

## 42. Evans Bros Hardware Shop, Menai Bridge

The High Streets of the towns of Anglesey are lined with rows of buildings that once housed the shops that fed and watered the populous and catered for their other needs: grocers, butchers, greengrocers, chemists, confectioners and ironmongers, amongst others. Through the years these traditional types of shops have often succumbed to the competition of supermarkets and chain stores. However, Menai Bridge is lucky in that

*Left*: Evans Bros shop.

*Below*: Behind the counter at Evans Bros shop.

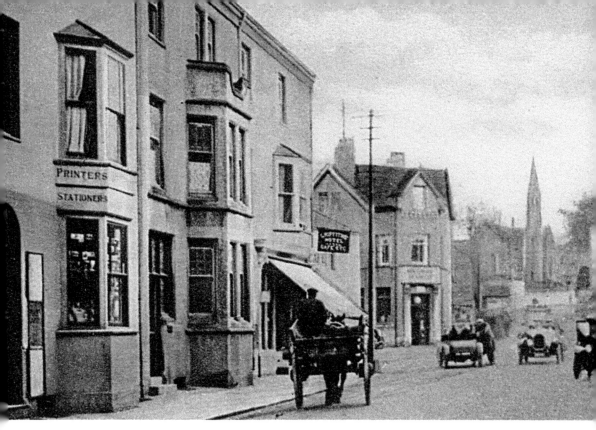

Nos 6 and 4 High Street, on the left, in 1914.

it retains a number of these old locally owned shops, alongside an increasing number of excellent restaurants and cafés.

One such shop is the Evans Brothers hardware shop. Walk in the door and it feels like you've been transported back several decades. The walls are lined from floor to ceiling with wooden shelves packed full with a chaos of cardboard boxes, bottles and jars. If you need a particular size of nail or a certain type of hinge, just ask; they will find it somewhere behind the counter. Elsewhere in the shop will be saucepans and plates, seed potatoes and dog food, electric drills and high-vis jackets.

This family-run shop was founded by Lewis (Llew) Evans in 1935 and was passed on to his son Elwyn Evans. Llew's grandchildren Ceri and Ian now run the shop, in much the same way as their grandfather.

The shop occupies what was previously two properties, Nos 6 and 4 High Street. No. 6, which is now the main entrance to Evans, was a private residence in the nineteenth and early twentieth centuries, occupied by Water R. Jones, solicitor and local councillor for many years. In 1911, it was occupied by John Grindin and his family. He was a gardener, originally from Jersey, but in the census he describes his house as a 'public library'. Perhaps he was also a book lover who allowed his ground floor to be used to house a fledgling local library. The public library was later located in Water Street, next to the Liverpool Arms.

After this it was a printers and stationers; old photos show stands of postcards out front and novels in the window. The adjoining property, No. 4, was used by the YWCA, where it ran clinics and youth clubs up to the 1960s, after which Evans Brothers expanded their shop into it.

The shop next door to Evans Brothers is also a family-run business with a long pedigree. The John Hughes Painter & Decorator shop was founded before the Evans Brothers, in the 1920s, and is still run by the Hughes family. Before they took it over it was the Railway Supply Stores, a grocers run by the Richard Herbert.

## 43. Bulkeley Square, Llangefni

From the time that Edward I built its castle and developed its town in the thirteenth century, Beaumaris was the principal town on Anglesey. However, in the late eighteenth century a small settlement on the River Cefni in the centre of the island acquired a cattle market. It grew in importance and eventually overshadowed Llannerch-y-medd as the main market town in central Anglesey. Its position on the main post road across Anglesey enhanced its prominence.

Llangefni grew in size and importance throughout the nineteenth century, even surviving the routing of Telford's new Holyhead road to the south of the town. In 1860, a county court building was constructed on Glanhwfa Road, beginning the process of Llangefni becoming the county town of Anglesey.

At the junction where Glanhwfa Road and Church Street meet the main commercial High Street through Llangefni, two prominent buildings were constructed. An inn called the Pen-y-Bont stood at this corner from the seventeenth century. It was renamed the Bull's

Llangefni Town Hall (left), Bull Hotel and Clock Tower.

*Above*: Drawing of the old market hall, with the Bull Hotel on the right.

*Right*: Llangefni Clock Tower.

Head in the early nineteenth century. In 1850, that inn was replaced with a much larger and more impressive building, three stories high, with prominent gables and a range of outbuildings housing the stables, tack rooms and servant's quarters. That building, in the seventeenth-century vernacular style, has changed little externally since then and is now a Grade II-listed building.

Next to the Bull is the equally impressive Town Hall. Before 1882 this site was occupied by a market hall, but Sir Richard Bulkeley, the local landowner, decided to knock it down and build a new town hall. This Gothic-style building was opened on 10 March 1884, celebrated with a concert by the Welsh Congregationalists and an Eisteddfod. The new building maintained an indoor market space on the ground floor, with offices, meeting rooms and the council chamber above. A balcony overlooking Bulkeley Square was used for public addresses to large crowds. The hall was badly damaged by fire in November 1992, but has been restored and now houses offices, with the market hall used for exhibitions and events.

To complete this triumvirate of interesting Victorian buildings, a memorial clock was erected in 1902. Built in the Gothic style to reflect the neighbouring Town Hall, it was dedicated to the memory of George Pritchard Rayner of Tre Ysgawen Hall, who died in the Boer War in 1900.

## 44. Ynys Farmhouse, Cors Bodeilio

Most of the buildings described in this book are prominent public structures. But, the vast majority of buildings on the island are private residences, both grand and humble. Also, being a rural area, many of them are farmhouses. This small two-room farmhouse called Ynys, in the middle of the marshes of Cors Bodeilio, is one of the most humble.

Welsh for 'island', Ynys might seem an odd name for a house, but closer inspection of the maps and surrounding topography shows that it is indeed built on an island of dry land in the middle of marshes. The house and surrounding nature reserve are now owned by Natural Resources Wales, but the mid-nineteenth-century records show that it was owned by the Right Honourable Lord Vivian of the Plas Gwyn estate in Pentraeth. It was leased to Evan Rice Thomas as part of the nearby Bodeilio estate.

The house was probably built in the 1850s; it doesn't appear in tithe maps and censuses until 1861. The first recorded tenants are Thomas Hughes, his wife Jane and sons William and Owen. As might be expected in a small cottage in the middle of pastures and marshlands, Thomas was an agricultural labourer, as was his fourteen-year-old son William. Eight-year-old Owen was not yet old enough to be working and was listed as a scholar, so was attending school. Thomas lived there at least until 1881, by which time he had been widowed and remarried to a much younger woman.

After this the tenancy of Ynys had changed hands to a shoemaker called William Williams, who lived there with his wife Ann and children Margaret and William. Curiously, his son William is listed in the 1901 census as a copper miner. Copper mining on Anglesey usually means Parys Mountain, but that is a long way from Ynys – probably around a four-hour walk. Perhaps he usually lived near the mine, but happened to be at home visiting his parents on census day.

*Above*: Ynys Farmhouse.

*Below*: View across the Cors Bodeilio marsh to Snowdonia Mountains.

The house has since been long abandoned and is slowly disappearing into the vegetation, now just home to the wildlife. However, the trees behind the house bearing delicious plums in the autumn hint at the domestic scenes that would once have graced this edge of the marsh.

## 45. Hermon Pillbox: Second World War Defensive Structure

Anglesey has been invaded many times through the millennia. Roman historian Tacitus vividly describes the invasion of the island by Roman troops, whose initial attempts to cross the Menai Strait in AD 60 were foiled by the fearsome Druids. Later invasions by Vikings were once celebrated on the island with the Amlwch Viking Festivals, and in the thirteenth century Anglesey and the rest of Wales succumbed to Edward I's armies. But, the threat of foreign invasions in the twentieth century has left visible marks all around the island, in the form of defensive structures and airfields.

One of the most distinctive and well-preserved ones is this Second World War pillbox at Hermon, near Bodorgan. It is one of several brick-built defensive structures that were erected to protect the RAF airfield on the Bodorgan Estate, which was the first one built on Anglesey in the early days of the war.

The structure of this pillbox (and its similar neighbours) is unusual and unique in the British Isles because it served several purposes. It needed to protect the airfield from incursions by land, sea and air. It stands beside the primary road leading to the airfield, with

Hermon Pillbox.

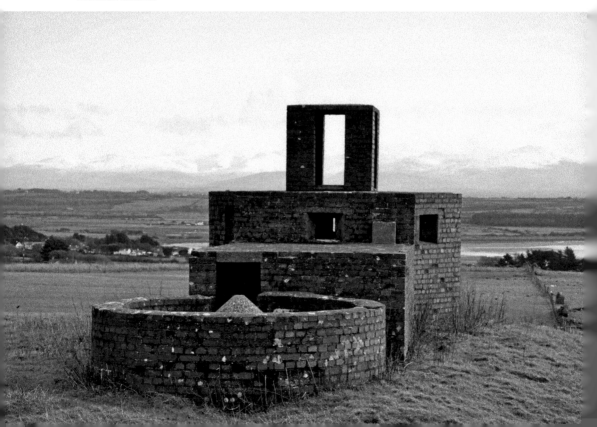

Site of Bodorgan airfield.

panoramic views of the Malltraeth Estuary (a prime place for a seaborne invasion), and near the approaches to the runways to protect against aerial bombing runs.

The circular section in the front of the photo was a gun pit; the conical structure in the middle was the mount for a light anti-aircraft gun. The far section is a hexagonal pillbox, with an opening on each side to act as a viewing portal and gun aperture. A hatch in the roof gave access to an observation tower. In the centre is the crew shelter, with a built-in fireplace to keep them warm.

Unlike the RAF airstrips at Valley and Mona, Bodorgan was abandoned as an airfield at the end of the war, with the buildings and land used for agricultural purposes by the Bodorgan Estate.

## 46. Our Lady Star Of The Sea Church, Amlwch

This is certainly one of the most unusual churches on Anglesey. Dedicated to Our Lady St Mary, as well as the seventh-century Welsh saint St Winefride, it was completed and consecrated in 1937. It was designed by Giuseppe Rinvolucri, an Italian from Piedmont who came to Britain as a prisoner of war in the First World War, but later married a Welshwoman and settled in Conwy.

With a nod to Amlwch's maritime history and proximity to the sea, Rinvolucri designed the church to reflect the shape of an upturned hull of a ship, complete with porthole-like windows near the bottom. These windows open into the parish hall on the ground floor, underneath the main body of the church.

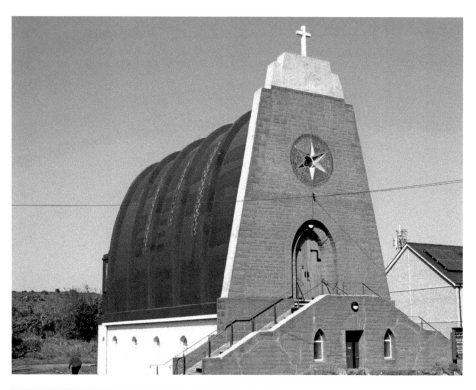

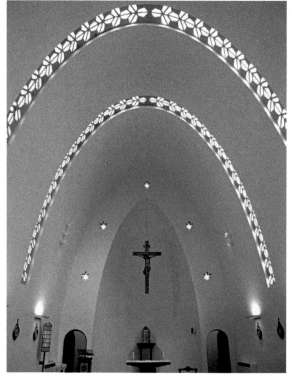

*Above*: Our Lady Star of the Sea Church, Amlwch.

*Left*: Inside Our Lady Star of the Sea Church.

The church was constructed of reinforced concrete in the shape of a parabolic curve. This allows the interior to be a simple but impressive space, with no intruding roof trusses or columns. The arched structure is highlighted from inside with a series of glass roof lights, which provide excellent lighting within during the day, as well as giving the building a stunning appearance from outside at night when the interior lights are on. The church also includes five small star-shaped windows on the north wall, around the altar, and one large star at the south end over the main entrance.

The façade of the church was originally mainly rough stone, with a smooth plastered area around the star-shaped window. It was like this until the late 1950s or early 1960s when it was completely covered over. The plasterer very carefully decorated the plaster so that it looked like finely dressed stone. The illusion is somewhat spoiled now by the recent appearance of cracks in the plastering on the side of the stairs.

Unfortunately, like many other twentieth-century concrete buildings, the church suffered from the coastal Anglesey weather. By the early twenty-first century, shortly after it had been given Grade II* historic building listing by Cadw in 2000, it was realised that the structure was becoming dangerous. It was closed in 2004 and demolition was considered.

However, fundraising efforts began and refurbishment commenced, initially focusing on repairing the external concrete walls/roof to stop the leaking, then on redecorating the interior walls and flooring, and installing a new altar. The church was reopened with a special mass on 1 May 2011 by the Rt Revd Edwin Regan, Bishop of Wrexham. It is now again home to a substantial and appreciative congregation.

## 47. Wylfa Nuclear Power Plant

Earlier in this book several power-generating buildings were described – windmills and watermills. These were the height of technology in the eighteenth and nineteenth centuries, but the rapidly growing demand for power throughout the twentieth century led to development of many other means of producing power. Nuclear power is one, and the UK led the world in developing the technology, with the first nuclear power plant opening in 1956, followed by many others at remote places around the coast.

Construction of a nuclear power plant at Wylfa Head, near Cemaes Bay, began in 1963. Its two reactors, each generating 490MW of electricity, began operating in 1971. For forty-four years it produced enough energy to power around 750,000 homes. The ageing plant ceased producing energy in 2015, five years after its initial planned retirement date. Work is now ongoing to decommission the plant, which will take several decades. Plans have been drawn up for a new nuclear plant on the site, Wylfa Newydd, but these have met considerable opposition and have recently been scaled down.

The closing of this and many other old nuclear plants around Britain, alongside increasing energy usage, leaves a gap in the electricity production capacity. For the past few years Anglesey has promoted itself as 'Energy Island'. Being a windy island near to the sea offers opportunities for alternative energy schemes. In the 1990s three wind farms were built near Wylfa, producing a total of 33MW of energy. More recently planning applications have been filed for many wind turbines around the island, although local opposition against these structures, which are often much taller than the old ones, has defeated many of these.

*Above*: Wylfa nuclear power plant.

*Left*: Wind turbines near Parys Mountain.

Other alternative energy schemes have also been explored. A solar panel farm was built on the Bodorgan estate in 2014 and now produces 15MW of electricity, and many others are under consideration. Innovative plans have also been proposed to harness the energy of the tides, using underwater turbines off the west coast of the island. Finally, the old Anglesey Aluminium smelting plant is currently being converted into the Anglesey Eco Park, which will host a biomass plant, producing 299MW of electricity by burning waste forestry residue and agricultural by-products. Excess heat and $CO_2$ from the burning will be used in adjacent greenhouses to grow fruit and vegetables and to farm prawns.

## 48. Seawatch Centre, Moelfre

The small seaside village of Moelfre is an important one in maritime history, mainly for famous shipwrecks. The most notorious was that of the *Royal Charter*.

On the night of 25–26 October 1859 an exceptional storm, considered the worst of the nineteenth century, hit Anglesey and the rest of Britain, with tragic consequences. That day the steam clipper *Royal Charter* was passing Anglesey on the way to Liverpool from Melbourne, Australia. Among the 490 passengers and crew were many miners returning

The Seawatch Centre and Dic Evans statue.

The RNLB *Kiwi* lifeboat.

from the Australian goldfields. In the hold were boxes full of gold, estimated to be worth £322,440 (tens of millions of pounds in today's money). Much more gold was being carried by the passengers themselves, in their luggage or sewn into their clothes. It was a ship of fabulous wealth.

As the storm intensified the ship was driven onto the rocks near Moelfre. Despite brave attempts to carry passengers along a rope to land, only around forty people survived. The wealth of the wreck ensured news of its demise spread around the world.

One hundred years to the day after this wreck, another ship, the *Hindlea*, was shipwrecked at almost the same spot. However, this time the much more capable communications and lifeboats gave its crew a much better chance of survival. Led by the renowned coxswain Dic Evans, the lifeboat crew fought hurricane-force winds for two hours to rescue all eight crew members. For this remarkable rescue Evans was given the Royal National Lifeboat Institution's Gold Medal for Gallantry, the first of two of these rarely given awards that he was to win. Four other members of the crew were also given silver or bronze medals.

The Seawatch Centre, established by the Isle of Anglesey County Council but now run by the RNLI, hosts an exhibition about the lifesavers of the island's coast. The main attraction is the Oakley class RNLI lifeboat *RNLB Birds Eye*. Launched in 1970, it was involved in ninety rescue missions, saving forty-two lives, before being retired and moved to the museum, where visitors can climb aboard and explore the vessel. Outside the centre is a garden area with exquisite views over the sea. A statue of Dic Evans provides the centrepiece. The nearby boathouse, first built in 1909, was replaced in 2015 with a new, modern facility erected to house the new Tamar class lifeboat, the *RNLB Kiwi*.

49. Oriel Ynys Môn

Most of the buildings in this book have a long history, but this purpose-built gallery and museum dates back just twenty-six years. It is a centrepiece of the island's arts and cultural scene.

The gallery was originally built to house the collection of one of Anglesey's renowned artists. Charles Tunnicliffe was born in Cheshire in 1901 and became best known for illustrating the covers of Ladybird nature books and the Puffin edition of Henry Williamson's *Tarka the Otter*. In 1947, he moved to Anglesey, setting up his studio in Shorelands Cottage overlooking Malltraeth Estuary and its abundant birdlife. When he died in 1979 his sketchbooks, measured drawings of wildlife and other works, which were seen to be of national importance, were purchased by the Anglesey Borough Council.

Planning began for a new centre for arts and culture on the outskirts of the county town of Llangefni. This would provide a space to store and exhibit some of the hundreds of items in the Tunnicliffe collection, as well as galleries for temporary exhibitions of other artists connected to Anglesey. A permanent exhibition about the island's history was also incorporated, with displays and artefacts ranging from prehistoric to twentieth century. The gallery was opened in 1991.

Oriel Ynys Môn.

*Above*: Exhibition hall inside Oriel Ynys Môn.

*Below*: History exhibition, Oriel Ynys Môn.

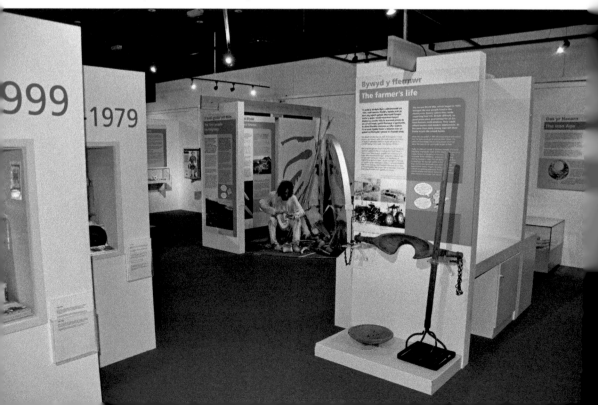

Tunnicliffe was not the only well-known artist on Anglesey. The Massey sisters, Edith and Gwenddolen, produced a large collection of detailed botanical watercolour paintings in the early twentieth century from their home, the Victorian manor of Cornelyn, near Llangoed. The inheritor of the estate put their work up for auction in 1982, which was purchased by the Anglesey council.

But, without a doubt the most famous Anglesey artist is Sir Kyffin Williams. He was born in Llangefni in 1918, descended from an old landed Anglesey family. He took up art when his epilepsy put a stop to his army career, becoming a highly respected member of the arts community in London. He retired back to Anglesey in 1973, where he continued to produce his distinctive palette knife oil paintings of the Welsh landscape and portraits of its people. He was a great supporter of the Oriel Ynys Môn and he donated more than 400 of his works to the gallery. At the time of his death in 2006 work had already begun on an extension of the gallery to house a permanent exhibition of his work and provide more display and storage space. It was opened in the summer of 2008.

## 5c. Halen Môn Saltcote, Sea Salt Plant and Visitor Centre

In 1983, two Bangor University graduates set up the Anglesey Sea Zoo on the banks of the Menai Strait, overlooking Snowdonia. It grew to become Wales' largest aquarium and

Halen Môn headquarters.

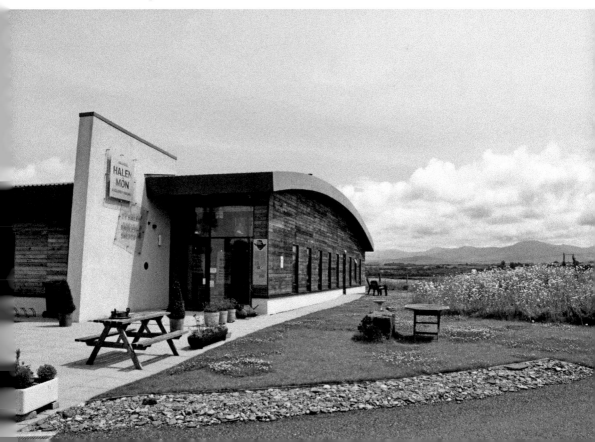

one of Anglesey's most popular attractions. However, the owners, David and Alison Lea-Wilson, were looking to diversify.

They already had a licence from the Crown to extract the exceptionally clean seawater from the Strait to fill their tanks. They spotted the possibility of producing sea salt from this clear water, and began experimenting with a saucepan and their Aga range. They discovered a process where slow evaporation would leave behind pure salt formed into unique crystals.

Over two years they developed the process, planned their packaging and honed their marketing. In 1999, they began supplying their Halen Môn/Anglesey Sea Salt to local shops. Their reputation grew and the salt has been increasingly widely used by top chefs and restaurants, and sold in delicatessens and supermarkets in over twenty-two countries. It is also used in products ranging from chocolate to crisps. In 2014, the name Halen Môn/Anglesey Sea Salt was given Protected Designation of Origin status, which places it alongside champagne and Parma ham as a product that can only be produced within a certain geographic area and using a certain process.

Halen Môn Sea Salt was initially produced in a small factory in part of the Sea Zoo buildings, with a window so visitors could view the process. As the business grew the Lea-Wilson's sold the Sea Zoo to concentrate on the salt business. In 2015, they opened a brand new, specially designed building, Tŷ Halen (or 'Salty Towers', as the owners are fond of calling it), housing the factory, offices and a visitors' centre and shop, from which they give tours of the factory. The attractively designed building, made of high-quality steel to resist corrosion from the salt and clad in Welsh larch, is the newest building in this book and enjoys panoramic views of the Strait and mountains.

# Acknowledgements

I'd like to thank CADW, Oriel Ynys Môn, Menai Heritage, Evans Bros hardware shop, and Hywel Meredydd Davies of Capel Cildwrn for their help while photographing their buildings for this book. John Cowell kindly provided old postcards of Menai Bridge High Street, the *La Marguerite* steamship, and Cloth Hall, Pentraeth, and Hywel Meredydd Davies provided the image of Christmas Evans. All other old images are from my own collection. All modern photographs were taken by myself, except the photograph of St Dwynwen's Chapel, which is by Ciarán Kovach. Finally, I thank my wife, Catherine Duigan, for all her help, interest and support while writing this book.

# About the Author

Warren Kovach is the author of the Amberley book *Anglesey Through Time*, as well as the popular Anglesey-History.co.uk website, which highlights aspects of the island's history, supplemented by many of his own photographs. Born and raised in Ohio, USA, he moved to Anglesey in the early 1990s and soon set about exploring its history and landscape. He has a PhD as a researcher in biology, ecology and palaeontology, but later moved to developing scientific computer software. He is a keen photographer and has had his photos published in many national newspapers, books and magazines around the world. He is also a trustee of the Menai Bridge Community Heritage Trust. You can follow him on Twitter at *@AngleseyHist* or on the *Anglesey History* Facebook page.